Artful Italy

Artful Italy

THE HIDDEN TREASURES

Ann S. Brandon

INVISIBLE CITIES PRESS

MONTPELIER, VERMONT

Invisible Cities Press
50 State Street
Montpelier, VT 05602
www.invisiblecitiespress.com

Library of Congress Cataloging-in-Publication Data

Brandon, Ann S.
Artful Italy : the hidden treasures / Ann S. Brandon.
 p. cm.
Includes index.
ISBN 1-931229-04-X (pbk.)
1. Art, Italian—Guidebooks. 2. Art—Italy—Guidebooks.
I. Title.

N6911 .B72 2001
 709'.45—dc21 2001039447

All photographs © 2002 by Carl Brandon except for the following,
which are reprinted with permission:

Fabio Saporetti: pp. 5, 7, 8, 10, 12, 14, 15, 17, 18, 19, 20, 21, 23, 24, 25
Art Resource: pp. 53, 54, 68, 73, 147, 149, 153, 169, 171, 184, 222
The Peggy Guggenheim Collection: pp. 57, 59, 63
Saulo Bambi: pp. 134, 139, 141, 144
The Bridgeman Art Library: pp. 150, 151
Frederic Stibbert (from *Civil and Military Clothing in Europe, from the
 First to the Eighteenth Century.* [New York: B. Blom, 1968]): p. 155

Printed in The United States

Book design by
Peter Holm, Sterling Hill Productions

FIRST EDITION

"One can forgive a place three thousand miles from Italy for not being Italian."

EDITH WHARTON, *Italian Backgrounds*

To my mother and father
con amore profondo

CONTENTS

Old and New Friends

Artful Italy could not have been published at a better time. The works of art that everyone feels they must see in Rome, such as Bernini's *Apollo and Daphne* and Michelangelo's Sistine Chapel, are today housed in atmospheres that perversely deny viewers the peace necessary to appreciate the art.

In order to control its huge crowds, the Galleria Borghese allots just forty-five minutes for each visit, rushing visitors through the dense collection and past the Bernini sculptures, several of which warrant an hour's examination. Asking visitors instead to fit the entire museum into less than an hour leaves them gasping.

The Vatican Museums, meanwhile, have electronically amplified the Sistine Chapel—where the pope conducted mass for centuries—in order to scold the crowds below in several languages, telling them to stop talking and put away their cameras. As a teacher I must go there, but as a lover and observer of art I loathe it.

Artful Italy suggests civilized alternatives or detours from the mainstream that I myself often take. Burrowing through Mithraeums that are cool, dark, and timeless offers a much-needed respite from Rome's heat and crowds. The houses of Mithra offer an excuse to spend a day in Ostia Antica, a bucolic getaway of ancient Rome that allows time and space in which to explore, observe, and contemplate.

I have lived in Rome for twenty years, primarily as a painter and teacher of painting and photography. I spend my

vacations looking at art all over Italy. I thought no works in Rome had escaped my notice. But even on my home turf, *Artful Italy* has pointed out frescoed rooms that I have never seen and that are a joy to visit. Now, after taking my students to San Giovanni in Laterano, I can also herd them to the nearby Casino Massimo to see the Nazarene frescoes. I want them to appreciate how a group of nineteenth-century artists rejuvenated the then dormant art form. The frescoes can only stir their imaginations as to why they are studying in Rome and how every niche of the city can influence their own work.

Outside of Rome, again some of the listings in *Artful Italy* are old friends, such as everything in Venice, while others I am now eager to meet for the first time. The Stibbert Museum in Florence is worth a trip slightly outside and above the *centro* just to see the painting by Carlo Crivelli. A single visit to Mantua's Ducal Palace, with its chivalric Pisanello frescoes and sinopias and its natural portraits in Mantegna's Camera degli Sposi frescoes, puts the town on one's northern Italy tour for good. And let us not forget that the palace has copies of the Raphael tapestries, allowing one less trip to the Vatican. Meanwhile, the Trivulzio tapestries in Milan I must have breezed by, and I will have to return to the Castello Sforzesco to reexamine them as an example of all that is rational, natural, and good in Renaissance art.

As an American living in Rome, I find companionship in Italy's art. I think of particular churches, paintings, sculptures, and frescoes as friends with whom I connect aesthetically, historically, and philosophically. *Artful Italy* has expanded my circle of friends to include some great and mysterious characters whom I will now visit regularly in order to come under their fascinating spell of beauty.

Lucy Clink
Adjunct Professor of Art, Cornell University Rome

ACKNOWLEDGMENTS

Without the voluntary help and friendship of many people whom I am lucky to know, *Artful Italy* would not have come to fruition. My shiniest badge goes to Jack Robertiello, who edited with a bemused eye. My father, John Eustice, planted the idea for the book long ago by filling our family library with art books and our heads with the stories of ancient Rome. Not to mention his more immediate help in translating the Latin verses on the Trivulzio tapestries. I thank my mother, Iona Green Eustice, in memoriam for her constant encouragement to "Go!"

Lucy Clink shoved me out the door to get the book done, read the book in draft, and painted Italian landscapes that are my constant companions and inspiration. Debbie Henry offered me bribes to meet my deadline. When they didn't work, Michael Grimaldi of Invisible Cities Press showed the patience of a true friend. Ralph Begley was the only friend to riffle through all my photographs and discuss every work of art, which helped me determine each chapter's slant, as well as what to keep and what to throw out. Peter Holm walked with me for months to work out the book's design before he even saw the manuscript.

Without the help of archaeologist Jan Gadeyne, I would have dropped the chapter on the god Mithra. Without the art

historian Carol Lewine's discourse on Raphael's tapestries, I might never have found my way to their history and meaning. Dr. Frank Duffy explained how the brain's quick disintegration after death prevents it from serving as a solid model for wax sculptures.

The staff and librarians at Dartmouth's Sherman Library of Art all acted professionally and considerately in helping me find resources. Lynne Gately of the Kimball Library also deserves a medal for her heroics in finding me interlibrary loans. The kind people in Italy who steered me onto the direct path are too numerous to mention, but I remember you all.

Finally, my husband, Carl Brandon, wins the gold star for driving fourteen hundred miles through the insane Italian traffic, hauling a tripod and several cameras up and down northern Italy, and taking five hundred photos. He then cooked dinner for months without complaining while I wrote. His largest gift to me, though, has been in having as much faith in me as he does in the Second Law of Thermodynamics.

A Score of Gems in
an Ocean of Treasures

I wrote *Artful Italy* as if I were having dinner with a friend who is going to Florence for her third time and wants to know what lies outside the Uffizi Gallery. I would not send her off with, "Oh, you've got to go see the churches, they're terrific," in the manner of most guidebooks. In a new and foreign city, most people feel at risk stepping off the main track. What if the church is not worth spending the entire afternoon and using one's elementary Italian to find the place? To persuade the friend that to hazard into the unknown is worth the reward, I describe the churches as fully as I can, bringing out art books with photos if I have them.

For myself, before any trip to an Italian city I skim the first and still definitive book on the country's hidden treasures, Giorgio Vasari's 1568 *Lives of the Painters, Sculptors and Architects*. Born forty miles outside of Florence in 1511 and dying in the city as he completed designs for the Uffizi Palace in 1574, Vasari lived during the great Renaissance of Italian art and was talented enough as an architect and painter to make friends with many whom he immortalized. He needed the stamina and craftiness of Ulysses to write about the earlier artists, sometimes traveling on bad roads during winter storms in frigid, jolting carriages. Arriving in a city with a Giotto, for example, Vasari had to finagle his

way into seeing the altars, which wary priests often locked away from public view.

With so much ground to cover, Vasari can dedicate only a couple of sentences to many works, can only hint at their beauty before moving on to the next masterpiece. Even with a tight leash on his enthusiastic pen, allowing only so many words per work, Vasari fails to cover everything. *Lives* weighs in at two volumes of a thousand pages each in ten-point type (Everyman's Library, 1996), which Vasari only occasionally leavens with an artist's portrait. The biographer of the quattrocento and cinquecento, as the Italians call the 1400s and 1500s, admits in his title that his work falls short. The original specifies that he describes the *Vite de' più eccelenti architetti, pittori et scultori italiani*—lives of the *most* excellent artists, which excludes the merely excellent.

Obviously, I leave the hefty *Lives* at home when I travel. The densest guidebooks, such as the Blue Guides, are also of limited use to the traveler. They'll offer a star or two to assure me that a fresco is worth seeing before they rush on to the church's other dozen paintings and sculptures, also all worth seeing. Travel books with many pictures and few words touch on only the most well known of artworks, and then just to supply a few meager details on the artist and an assurance that the works deserve the title of masterpieces. I've written *Artful Italy* to fill this void in the available literature and offer the enlightened traveler a personal and detailed tour of art in northern Italy, down to Rome.

By its very nature, mine is an idiosyncratic travel guide. I cannot claim that these are the only or the best works to see. To do that, I would have to write an encyclopedia. The best reference on just Florence's churches, for example, is available only in Italian and comprises several huge volumes. I once

saw a comprehensive work in Italian on the art of the areas surrounding Florence that filled two tomes. Even UNESCO, which prides itself on shunning a Eurocentric view, has estimated that 60 percent of the world's greatest works of art are in Italy, and half of those are in Florence.

The works of art that I have chosen all lay claim to having influenced art history. They are not the biggest and brightest stars of the Renaissance constellation; any guidebook tells you about those. These are, instead, the works that many art historians and, more important, artists, sculptors, architects, and archaeologists consider their personal favorites. These churches and paintings speak to the artist through the usually impenetrable walls of time and space to bring out the excitement and awe of first love.

Many of the painters I know, for example, revere Carlo Crivelli, though he spent his life in exile in the Marche region, where he could meet no influential patron to launch him into the mainstream of Renaissance art. Venice's Gallerie dell'Accademia excludes his three paintings in its collection from its guidebook. Yet those who know his work rush to see *St. Jerome and St. Augustine* first among all the Accademia paintings that encircle it like small constellations. The church Sant'Ivo alla Sapienza in Rome cannot compete with St. Peter's, but many architects plan the day's itinerary around visiting Borromini's masterpiece—not difficult, as it lies between Piazza Navona and the Pantheon—to soak in the details of its quietly moving interior and eccentric campanile.

The wax anatomical models in Florence's generally unknown museum La Specola reveal the human body's mechanics for doctors and surgeons and its beauty for sculptors and painters. The suggested itinerary in Venice has some well-known pieces, some lesser-known ones, but my hope is

to encourage you to spend as much time as possible out walking the city streets. The light and the waterways' quiet have influenced writers, painters, choreographers, and composers since the time of Attila the Hun. The garden at Bomarzo outside of Rome is not full of "great" sculptures but reflects how wealthy aristocrats of the Renaissance invested both financially and emotionally in the new, and how the collaboration between a scholarly artist's imagination and his patron's mourning can result in images that still shock and bemuse.

In writing and editing the book, I find myself wanting to rush back to Milan to look at the Trivulzio tapestries more closely and give them the time they deserve. I cannot wait to return to Mantua to discover more intimate details in the portraits of the Gonzaga family in the Ducal Palace's Camera degli Sposi. All of the art here has given me years of deep pleasure, and I am confident it will also delight many more who take the time to appreciate it.

Artful Italy

Milan

Milan is an acquired taste. Usually travelers arriving at the airline hub spend only a requisite night before traveling south. Those who are accustomed to withstanding large, disharmonious works of art to discover beauty and delight, such as epic poetry readers and Wagnerians, are more likely to stay longer.

Celtics founded Milan. Romans grabbed it away from them in 400 B.C. and rebuilt it with an engineer's penchant for strong bridges and wide highways. But the city's foundation layers up from the original northern bones, which leach their appreciation for the hard and cold into the city's aquifer and then into its culture. Though second to Rome in population, Milan comes first in Italian finance, trade, fashion, and industry, all thriving in the northern spirit of international competition.

Like St. Mark's in Venice, a single building in Milan, the Duomo, attracts flocks of visitors who lounge and enjoy the large palazzo, the cacophony of languages around them, and the opportunity to appreciate art and architecture from a comfortable stoop that one gladly shares with pigeons. The Duomo has no circle, which would waste space and offend the northern utilitarian ethos. Tall and linear, dressed in the city's fashion code of black and gray, looking more like a gathering of stalagmites in a monochromatic cave than a major tourist attraction, the Duomo is the prototype for Milan's skyscrapers. The cathedral is not a museum piece that warns its visitors and residents to look but not touch. You can climb

unescorted to the top, but it is a difficult and seemingly endless journey.

Once you leave the Duomo, you are no longer in a wellkept museum of a city. Milan is definitely twenty-first century. It embraces the world's people and cultures and offers visitors more diverse choices than any other major Italian city. Milan actually has a guide to ethnic food, available at some museums, in which, unlike any other major Italian city, the cuisine ranges farther south than Calabria.

Milan resembles a modern orchestra in which each musician plays her own tune. The couturiers are not all Italian, the museums have collections that expand past the saints and the Madonna and child, and the businesses sell to city residents and other businesses rather than just to tourists.

Milan does not demand, as Venice does, that you love her as you might Tosca's aria, and it does not play on your sense of doom like *Traviata*'s overture. The city requires several visits, or listenings, before the harshly modern rhythms blend well enough with its deep European tones to make sense and even result in some recognizable tunes. Just as Mark Twain thought Wagner's music to be not as bad as it sounds, you will realize that Milan is not as bad as it looks. With each viewing, you will hear more of the music and less of the noise, and you will enjoy the rich orchestra that plays over the industrial drums.

Tapestries of the Months

The tapestries of Trivulzio now at the Castello Sforzesco were born during a sliver of Milan's history. On September 2, 1499, Gian Giacomo Trivulzio seized Milan for the French without firing a shot. He drove out Ludovico Sforza, of Milan's greatest

ruling family since the Visconti, for whom Trivulzio used to fight until he switched loyalties to the French. His reputation and that of his troops had preceded him; they were known to be lenient toward towns that surrendered without a fight and unmerciful to those that did not. Shortly after receiving the keys of the city from Trivulzio's hand, Louis XII named him Maréchal of France and Marquis of Vigevano.

Known simply as "the Great," Trivulzio commissioned the Tapestries of the Months from Bramantino, a disciple of the great architect Bramante. Trivulzio wished to convey the message that under his tutelage the people experienced peace and prosperity. Once the king left Milan, however, Trivulzio could not curb his French soldiers' appetites and violence. The Milanese were forced to quarter their armed enemies, who considered the homes to be their private brothels, banks, hotels, and mess halls. They used Leonardo's clay model for a gigantic equestrian funeral monument to Ludovico's father as target practice, sealing Trivulzio's reputation as a *cretino*, or cretin.

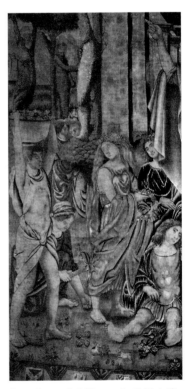

Benedetto da Milano, *April* (detail), woven from a cartoon by Bramantino.

Born in and exiled from Milan, Trivulzio promoted only partisans, relatives, and Guelphs to government offices and threw out or insulted competing Ghibellines. He meted out justice with arbitrary arrogance, dictated what

he wished, and ignored the French-Italian council that Louis XII had carefully established. Though Trivulzio reduced taxes from Ludovico Il Moro's extortionist rates, the Milanese nevertheless began to wax nostalgic for the good old days with their "Moor." Trivulzio was forced to flee the city with his tail between his legs on February 5, 1500.

However, in those nine short months the French marshal managed to lay the foundation of what proved to be a long French rule, and commissioned a modern cycle of tapestries. Bramantino and the weaver Benedetto da Milano stayed behind to start the tapestries, which they completed over the next nine years. The art of Italian tapestries began with Trivulzio's short reign, for the twelve tapestries are the first noteworthy examples of Lombardian weaving.

To celebrate what he thought would be his own long rule and to break from the traditional seats of power—the Sforzas' and the pope's—Trivulzio chose icons of radical modernity, of rationality rather than of Christianity, and of earthly joys among earthy people rather than of chivalry or piety. Peasants and courtiers dance, drink, work, and live the months in joy and despair, birth and slaughter, sin and penitence.

Trivulzio found the right artist to portray him as a chosen rather than hereditary potentate. Trained in Milan, Bramantino had studied the new perspective in composition and in drawing the human figure when he visited Leonardo da Vinci and Piero della Francesca on a journeyman's tour through central Italy. The tapestries' realistic vignettes break from the medieval tradition of depicting fantasies—a unicorn has no more place in the Trivulzio Months than on a Milan street—and Bramantino employs formal geometry to bring them to life.

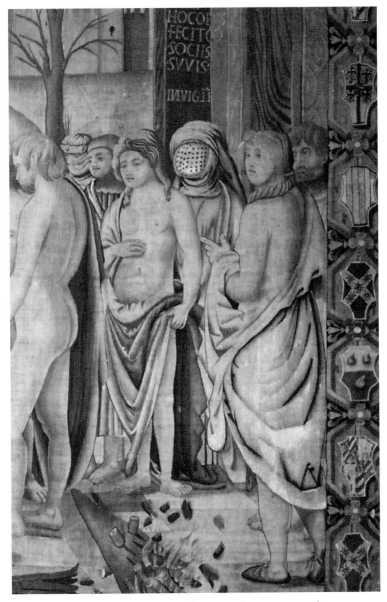

Benedetto da Milano, *February* (detail), woven from a cartoon by Bramantino. A repentant woman wears a mask during either Lent or a more pagan ceremony of cleansing and redemption.

The tapestries observe the Great's subjects as they prosper under his generosity and the peace he enforces. He follows his family motto and "never strays" far enough to allow the viewer to forget who is the real creator of the scenes. A monotonous repetition of Trivulzio's many coats of arms frames the tapestries and adds little. (To compare, look at the scenes from Leo X's life that frame Raphael's *Acts of the Apostles* tapestries at the Vatican.)

What actually detracts from the Castello Sforzesco tapestries' beauty, though, is the large and ugly medallion that disrupts the center of each tapestry with the Trivulzio coat of arms, which comprises a variety of initials that all spell "ME!," the insignia of a siren breaking a diamond with a blade, and the family warning, *Netes mai,* or "Stray not." Yet the real protagonist behind the tapestries, Bramantino, proves talented and humorous enough to help us ignore the Great's vanity. Bramantino distracts from the central medallion by bookending it with the charming suns and constellations and overshadows it altogether by bestowing elegance on the architecture, lusciousness on the fruits and vegetables, and candor on each man, woman, and child.

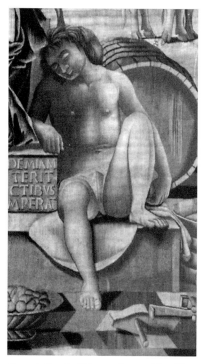

Benedetto da Milano, *August* **(detail), woven from a cartoon by Bramantino.**

Bramantino imagines the sun and its moods in an

entirely original manner. On the left-hand corner of each tapestry, the Sun's aura reflects the waxing and waning of the hot seasons. Its facial expression is blank but not cartoonish, and increased shading around the eyes and mouth subtly reflects the rise in temperature in spring and summer.

With the constellations, however, Bramantino takes his images from wood prints that illustrate Ignio's *Astronomicon*, published in Venice in 1482. Here Bramantino first saw Virgo carrying Mercury's staff, as in the *August* tapestry, and the Twins bearing a scythe and a lyre, though he turns Ignio's scandalously clad teenagers into *May*'s charmingly naked babies. Also in *Astronomicon*, Scorpio carries the scales of Libra, which explains why the *September* and *October* tapestries share the same icon, though the symbol predates the book.

Born Bartolomeo Suardi, Bramantino took his name from Bramante, the architect of St. Peter's Basilica and Michelangelo's rival. Bramante's penchant for painterly and dramatic effects in churches reappears in his disciple's architectural images, even when rendered in ignoble wool and silk rather than in stone. Living up to his nickname, Bramantino creates designs that are more stage sets than realistic portraits of Trivulzio's court, barns, and granaries.

Bramantino's human figures dim those woven before the Months. High Renaissance in their outline, elegant and lithe and fully plastic in their range of motion, the Trivulzio figures were an innovation in tapestry design, and seminal to Raphael's work. The "watchers," or portraits that stare straight out of each tapestry and compel viewers to stare back, are even more modern in their consistently brazen personalities. They refuse to be dismissed as museum pieces. Their eyes never venture into the melodramatic but connect in friendship across four centuries, sharing our common joy

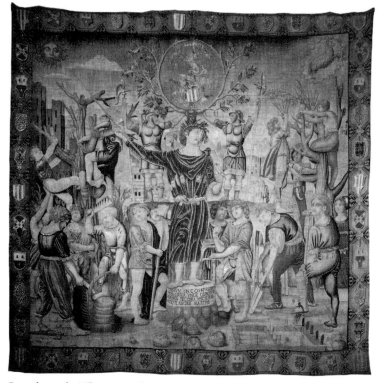

Benedetto da Milano, *March*, woven from a cartoon by Bramantino. This tapestry begins the year.

in spring's arrival, our suffering from August's intense heat, and our despair at the endless monotony of January and February.

March contains one of the most sophisticated voyeurs: a fair peasant rests in the far right corner and glances from under his handsome eyebrows to wonder at our passing, as curious to see us as we are to see him. This tapestry starts the year *("Annum incohat")*, as was still the tradition in Florence and Rome but not in Lombardia, where the tapestries were woven by Benedetto da Milano, who probably set up his atelier in Trivulzio's castle at Vigevano, southeast of Milan.

Wherever Trivulzio landed—France, Milan, Asti, Vigevano—he needed a 150-foot-square room to display his tapestries against the walls. He wanted to stand in the middle of the room and have his eye guided around to the left, the direction in which the tapestries' main allegorical figures point. The movement is counterintuitive to the march of time, which circles right like a clock's hands. Designed forty-three years before Copernicus shot the earth from center stage, the tapestries illustrate the turn-of-the-sixteenth-century belief that the sun orbits counterclockwise around the earth. The tapestries' central figures point to the sun in its various seasons in the upper left; their fingers also flip the calendar pages forward for viewers by directing us to the next month. Unfortunately, in the Sala della Balla, where the tapestries are currently displayed in Castello Sforzesco, the tapestries face each other in the middle of the room, with only a few against the wall to give one a sense of time circulating. What's more, their colors are muted, the lights having been dimmed in order to preserve the fabric.

The sun also symbolizes the Great: humanistic, rational, masculine, all-powerful. After the sun, Trivulzio's next symbol of power is the oak and its leaves. In *March,* the tree frames Trivulzio's medallion, the single frame in which Bramantino emphasizes the monograms of ME. Roman soldiers pose with an arborist's pride before the oak's singular leaves, for all the other trees are still bare. The inscription reads:

March begins the year,
The world resonates.
Everything grows;
Humans and animals,
Fish and birds quiver with love.

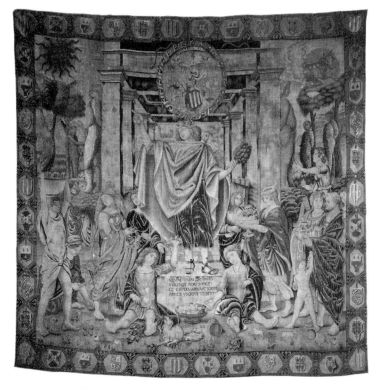

Benedetto da Milano, *April*, woven from a cartoon by Bramantino.

Farmers graft trees under the burning sun and prune under prancing Aries, while others till the soil and repair the tools that lay idle and rotting over the winter. Beneath the allegorical figure, the faces of the four winds whistle. The most curious feature in all the tapestries is the tiny heads that peek out from beneath March's shirt, a symbol of birth grafted onto a masculine chest. Yet March is essentially a feminine month of birth and of tending newborns. He looks as if he is sprouting breasts and resembles more an Oriental fertility goddess than a powerful man-at-arms.

In *April*, except for a lone woman carefully seeding on the left and an arborist on the right, peasant and courtier alike

stop all pretense of labor to enjoy the spring. The inscription proclaims:

April only gives life.
She makes flowers reflower upon flowers.
She makes joy and jokes,
And everything resplendent.

March's grafting and pruning have so rejuvenated one tree that in *April* it sprouts not only leaves but also a head and belly that Bramantino catches in an exuberant dance. The more static topiary trees also reveal small dramas. The cupid on the left is the romantic complement to the Satyr and his minions on the right. A peasant snips the man-goat (beneath Taurus's nose ring of stars) with long shears pointed in an obvious joke to make male viewers defensively cross their legs: Italian humor has not changed radically since the early sixteenth century.

In *May,* the courtiers have left the stage. A round structure replaces *April's* square-cornered walkway through a formal flower garden, and the figures stand among the vegetables. Two boys in the front pluck lovage. Bramantino carefully exhibits the farmers' tools, as if for a museum of rural life: spades for rocks and hoes for grubs, sickles for the undergrowth and rakes for the cuttings, weeders for every vegetable that will spill out of the following months' cornucopia.

May sits with the earth literally beneath his left foot and thus must represent Trivulzio. In fact, he seems more man than allegory here, in contrast to the figures in other tapestries. As May, he is a manager who uses his free hand to choose the younger of two fruit trees to transplant; in his other hand he loosely holds a stick to indicate the sun, which

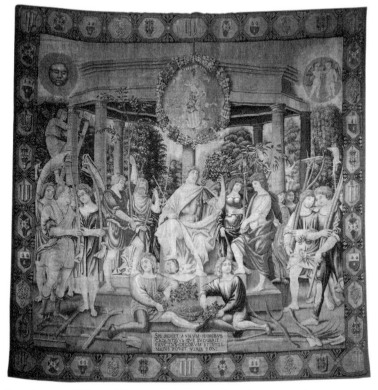

Benedetto da Milano, *May*, woven from a cartoon by Bramantino.

has mellowed from intensely sharp rays to a beneficent halo. The Gemini babies carry tools just like the grown-ups but, considering their size, could never employ them; they add innocence and levity to an otherwise industrious scene. The inscription celebrates:

> *May fills the year with hope,*
> *Tosses flowers to reveal fruit,*
> *And favors both the beautiful*
> *And the useful of spring.*

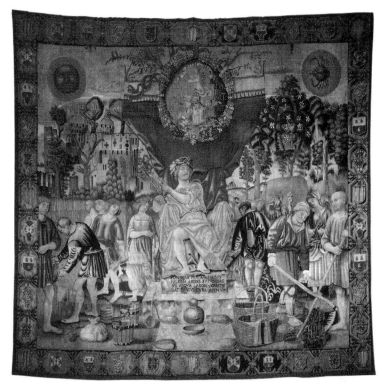

Benedetto da Milano, *June,* woven from a cartoon by Bramantino.

June returns to the farmers' world and shows them placing their tribute outside the castle walls. If an attempt to popularize taxation, the tapestry was too late to save Trivulzio. Historians blame his quick demise mostly on the Milanese grumbling over his asking them for any tribute at all, even though his first act as governor was to cut the tax rate. Two young men no longer anchor the tapestry's bottom center, where instead we see the grass covered and laid with bowls and soup spoons, a flagon, and buckets of milk, which indicate that the farmers will soon break for a communal meal. Beneath June's feet the inscription reads:

Every year, June gives farmers
Their annual chore of trusting
When to put the scythe to the dry crops
And hay the meadows.

July's scene is the most dynamic and single-minded of the twelve, with only one figure (beneath the hot sun) in repose. The surrounding building and background of a cityscape make the farmworkers appear to be in Trivulzio's compound, or at least within walking distance of Milan. The men are all at some stage of threshing grain. Workers break up the wheat on straw mats in the foreground, while a man stands poised in the left back to winnow the pulverized sheaves by launching the pile up in the air, windward. A small bucket lies optimistically before the large heap, ready to catch the object of all this hard labor: pure grain. The blue-robed beater on the right is finely drawn and articulated, shadows and ripples making visible his every muscle on the downstroke. The central allegorical figure for the first time looks at us, albeit in a lopsided tilt, his right arm full of wheat as he stands on the harvest month's inscription:

By filling the granary, July rewards
The farmers' sweet sweat
That separates the wheat from the chaff
On the crackling threshing floor.

As *July* is simple—separate the chaff from the grain— *August* is complex. The Bacchus-like master of ceremonies looks from his party again directly at us, as if wondering how we could let something as trivial as time keep us from joining the winers and diners who, on both left and right middle ground, also gaze at us. They are evidently the only ones in the

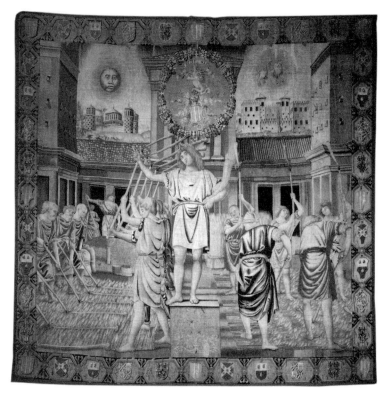

Benedetto da Milano, *July,* woven from a cartoon by Bramantino.

crowd sober enough to notice visitors. The naked drunks who litter the scene, including a baby on the left, are sick from too much nouveau Gavi wine, though drinking even a single cup could have upset their stomachs: bottles did not come into use until the eighteenth century, and until then temperature changes and travel easily spoiled wine. (The man on the left pours wine out of what looks like a broken bottle, but the neck of the sheath he squeezes, unlike glass, is flexible.)

August also is the month of a desiccating wind, the sirocco. Fresh fruits are its antidote. (They also combine well with wine for an Italian-style sangria). The "ill wind" carries

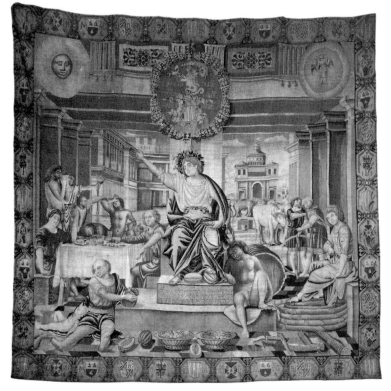

Benedetto da Milano, *August,* **woven from a cartoon by Bramantino.**

red sand up from Morocco and spreads through Italy a curse of depression and insanity. Notice that the sober couple has just finished a large *macedonia* (fruit salad), while the man under Virgo bathes his feet to keep himself cool during Italy's hot-breathed month. The inscription reads:

> *August heralds the grape harvest*
> *For the god Bacchus,*
> *Grinds the millet, and tempers passion*
> *And the new harvest with wine.*

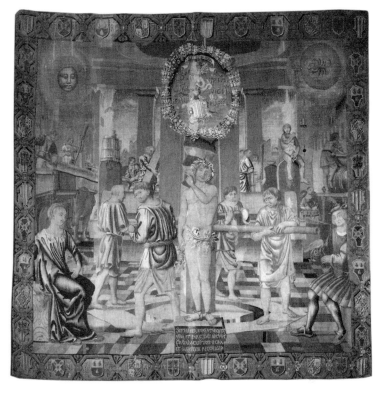

Benedetto da Milano, *September,* woven from a cartoon by Bramantino.

The farmers regain their good spirits by *September,* where another Bacchus-like figure stands at the hub of a wheel of peasants performing the brutal work of beasts: pushing the grape press wheel. The slavish attitudes highlight the royalty of Gian Giacomo Trivulzio (seated under the ancient symbol of a scale-toting Scorpion, thus representing both power and justice but not much love) and his second wife, Beatrice (under the waning sun). In the background, Bramantino (to return to the true hero) illustrates the various stages of wine-making with clever intricacy. Grapes roll down an open shoot and into a funnel to the press in the back right, where serfs

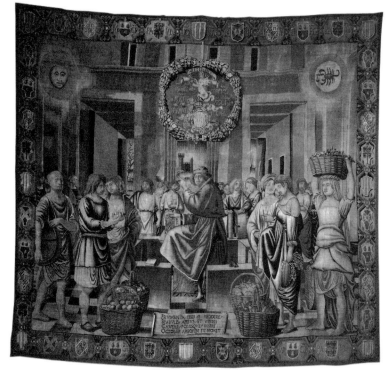

Benedetto da Milano, *October,* **woven from a cartoon by Bramantino.**

hand-sort for debris and dirt. (Italian gentry still kept serfs. Trivulzio's contemporary in Mantua, Isabella d'Este, earned a reputation for humanity by referring to one in a letter as a "man" who did not deserve to be punished as an animal.) Bowls are perched for testing the liquid before it is siphoned into barrels, on the far right, where it will spend many months fermenting. The inscription reads:

September ripens the grapes
And prepares to give the wine
To the birdcatcher to make up
For the month lost in hedonism.

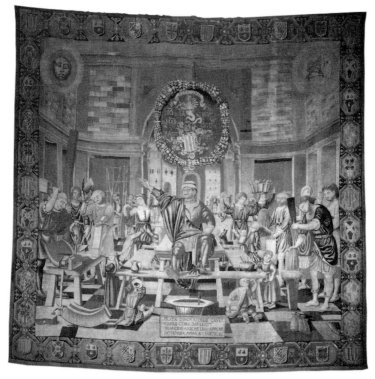

Benedetto da Milano, *November,* woven from a cartoon by Bramantino.

In *October,* Trivulzio is in power again, gathering tithes from his subjects. Carrots, apples, pears, potatoes, and greens are all finely drawn as they lie piled high in baskets. October is an accountant, with his book on one side and pen on the other, representing business and profits made. The inscription says:

> *October restores field crops to the barn,*
> *Guards the handiwork*
> *Of the trellises and vines and fruit trees,*
> *And warns trees that they will be grafted.*

Like March, November is a month in which to prepare for

future labor. The farmers repair and sharpen tools and set up their work tables for various tasks. On the right they comb and beat flax, while on the left, even the young girl has a serious bundle clasped in her arms. Only the children eat and drink and excitedly leap for new shoes (middle right). Everyone else hammers, saws, whittles new harvest tools, and puts away the old ones. The inscription reads:

> *Meadows rejuvenate, forewarn of olive oil.*
> *Farmers come together in November*
> *To pluck the fruit and gather the nuts from the trees*
> *And prepare their flax and tools.*

December is real work and real play. The vignettes poetically show how pig slaughtering brings out both the murderer and the lover in us all. In the Renaissance, epicurean laboratories figured out how to preserve innovative cold meats. By the fifteenth century, pork carvers had established their own guild. Italian towns imported workers skilled in butchering from the Umbrian town of Norcia; the new citizens were called Norcini. Pig entrails became sausage cases or smoked budalacci, the cheeks lard, the head and neck capocollo sausages, the liver mazzafegati sausages, and the haunch prosciutto.

The men and women carrying bowls for the blood (two stand under Capricorn) evidently consider the slaughter a sacrifice, given their pious expressions. The floor is tiled and thus easy to clean of offal, fruits dot the foreground as garnish to the main meals of blood sausage and pork, and, for the first time, children play with the grown-ups rather than by themselves.

The central figure resembles Father Time with his sickle, and the sun a man on his last gasp. Behind the utilitarian

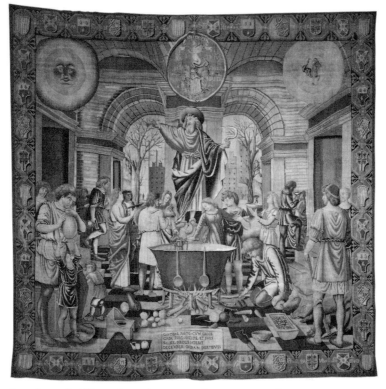

Benedetto da Milano, *December*, woven from a cartoon by Bramantino.

brick arches lies a cityscape that could be Sempione Park (behind the Castello Sforzesco) or even Manhattan's Central Park. Father Time waves his arm at the ailing sun and lifts his sickle, and the two archways peer like binoculars into the future of Milan. The inscription reads:

> *Rejoice in birth,*
> *When the flocks fill the house.*
> *The birdcatcher and his kind mount,*
> *Increase their offspring.*
> *December works for the slothful.*

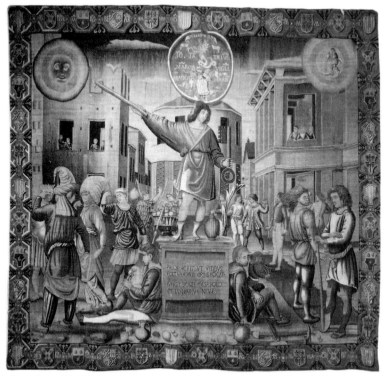

Benedetto da Milano, *January*, woven from a cartoon by Bramantino.

January sports the two heads of Janus, yet a carnival of dancing and celebration more appropriate to February surrounds him. In fact, *February*'s inscription says "January"—a "weavo"!— but depicts a Lent-like scene that looks more like March. The Trivulzio calendar does not quite fit the year and could use another month between the last month, February, and the first, March.

January's dancers cover their faces and legs against the bitter winds and enjoy the courtier's life while a few peasants (under Aquarius) spade the hard earth for spring. Others watch in the background from the comfort of their heated high-rise apartments, just like in today's Milan. In the fore-

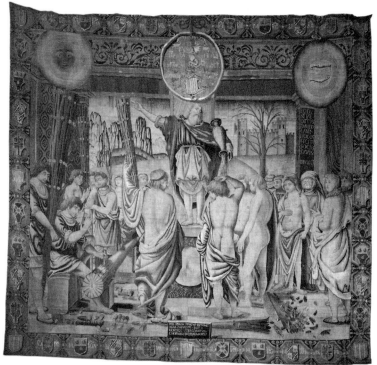

Benedetto da Milano, *February*, woven from a cartoon by Bramantino.

ground lies the equipment for a feast: jugs and bowls, glasses and bread. The inscription reads:

> *January snows,*
> *Sharpens the spade for tilling the vineyard,*
> *Yokes the cattle in a single throw.*
> *The foul fowl call.*

February's image of a religious ceremony could be either pagan or Christian Lent. The mostly nude figures ready themselves for a ritualistic cleansing, as symbolized by the central figure pouring water. One penitent hides her vanity from the

world behind a mask (under Pisces), and all prepare wood fag-
gots for a bonfire, already begun in the right foreground, to a
saint or idol. The fire might also be for self-excoriation, to end
in purification by water, which February pours over a suppli-
cant. The inscription reads:

> *Through the fallow fields the till*
> *Cuts fodder for the fire,*
> *Fertilizes the flowers,*
> *and January* [sic] *leads the dances.*

His battle scars did not earn Trivulzio more than a few
footnotes in northern Italian history, for handing Milan's
head to the French and for losing France's Italian stronghold
at the 1513 battle of Novara. A lifetime spent in savvy polit-
ical maneuvering reached its unimpressive zenith when he
became godfather to Louis XII's daughter, Renée. On the
other hand, his art commissions, even those not realized but
momentarily desired, have immortalized his name. Recalled
to Milan in 1511, Trivulzio commissioned Leonardo da Vinci
to build him an equestrian funeral monument with eight fig-
ures, six harpies, and more. Leonardo's sketches for the statue
and *Gli Arazzi Trivulzio* vindicate Trivulzio as a man of vision
and culture who employed artists better than soldiers in
giving them their head and allowing them to break the rules.

Castello Sforzesco

Hours: 9:00 A.M.–5:30 P.M.; closed Monday.

Admission: Free

Telephone: 02 884 63 703

Getting There: Take the metro to the Cairoli stop. Get
off there and walk down Via Beltrami. Castello Sforzesco

stands in the middle of Foro Buonaparte. To get to the Sala della Balla, where the Trivulzio tapestries are displayed, walk off the street into the museum's main entrance, which leads to the castle's first courtyard. Walk across the large courtyard and admire the castle's Romanesque architecture. Turn left under the arches. Go up the stairs, examine the Roman torsos on the outer wall, and continue up the stairs until you reach the Sala della Balla.

The Sala also contains historic musical instruments, including Giuseppe Verdi's organ. The museum displays many other Renaissance and ancient artifacts; its prize is the Rondanini *Pietà* (1553), which Michelangelo sculpted in his last years as his final, though unfinished, masterpiece.

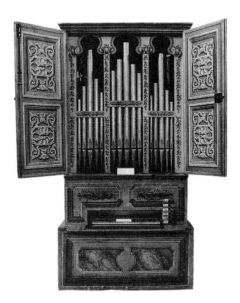

Orta

Sacro Monte:
A Tribute to the Life of Saint Francis

Then the poor people fight
to follow him, whose miraculous life
is glorified best when sung on high.
— Dante, *Il Paradiso*, Canto XI

In Italy's northern Lake District, three "Sacro Monte" dot the countryside. The parking lots near each are filled with buses, usually on Christian-themed tours. Yet Orta's unique tribute to Saint Francis of Assisi is not meant for Catholics only. First, Orta's Sacred Mountain contains a beauty that transcends religious dogma. (Nietzsche fell in love with the young Russian Lou Salomé while they visited the chapels together here, and kissed her in front of one of the ornate iron gates.) Second, St. Francis himself is more a universal than a purely Christian figure. The nondenominational Alcoholics Anonymous suggests St. Francis's prayer to its members to relieve anxiety. New-Agers sometimes pair a statue of St. Francis standing with a sitting Buddha.

Third and finally, Francis is arguably the world's most recognizable saint, consistently portrayed in his simple brown robe cinched at the waist with a rope, standing with his arms stretched to give birds a landing perch while chipmunks lean on their haunches for a better look at the blissful friar. Orta's tableaux of sculptures and frescoes offer a chance to expand our dictionary of images for the beloved patron saint of Assisi.

The abbé Amico Canobio of Novara founded the Sacro Monte in 1590 as a monastery. The following year, he began to build the tribute to St. Francis's life, using his own funds and those of the town residents. Also listed among the contributors are a few Milanese who summered on the lake island San Giulio in opulent "cottages." The park's secondary founding father is the Capuchin monk and architect Father Cleto of Castelletto Ticine, who deserves full creative and artistic credit for the rambling museum. He designed more chapels than any of the other architects and determined the sanctuary's aesthetics, from which other builders and sculptors could stray but so far. He also took care of the minutiae

of realizing the twenty tableaux, including building giant kilns on the property in which the sculptors fired their terra-cotta figures.

Though St. Francis is officially the patron saint of ecologists, most people revere him for his steadfast pledge of poverty. St. Francis called poverty his "bride." Giving money to the Franciscans for many has been a sure way to assuage guilt over wealth. St. Francis thought even clothes unholy. He followed Christ's edict of giving his tunic as well when someone asked for his cloak. As he lay dying in the Porziuncola Chapel, near Assisi, Francis stripped himself naked in order to meet his Maker pure of possessions.

It took a century to build twenty chapels and fill them with frescoes and statues that illustrate St. Francis's *mirabil vita*. The scenes' aesthetics at first adhered to those dictated by the Council of Trent. The statues tell their stories with elegiac simplicity and, especially when showing St. Francis's birth,

delineate between peasant and aristocrat with a clarity that the illiterate can easily grasp. By the middle of the Baroque movement, however, when the last chapel was completed, the artists emphasize the dramatic, rendering each of the many statues with a distinct and fascinating character.

Orta's Sacro Monte contains jewel-like architecture, and every chapel deserves to be examined as a work of art in itself. The frescoes are animated, the statues etch themselves into the mind's eye, and the iron gates are so exquisitely wrought that the chapel's legends name their welders. Yet the museum does not limit itself to what is inside, outside, or immediately around the chapels. The work of art called Sacro Monte d'Orta cannot be fully described without mentioning the landscape.

In addition to being the prominent architect, Padre Cleto masterminded the Franciscan peninsula's woods and gardens. He laid out the terrain and walkways specifically to encourage visitors to pause, rest, and enjoy the natural beauty of the lake and its surrounding hills. The Franciscan monks wanted to imitate their patron saint in evangelizing an ecstasy over nature's beauty. As a result, the entire Sacro Monte d'Orta promontory is now a nature preserve. Designed to frame the art, the landscaping proves to be almost as eternal as the frescoes and sculptures. Some of the original bushes and trees planted by Cleto still live, such as those that line the pilgrims' trek up to the shrine.

The Sacro Monte was considered a sacred place long before the Orta community banded together in 1583 to provide a convent for the Capuchin monks. They worshiped at the wooden statue of the Madonna della Pietà, which is still housed in the church of Saint Nicola, whose foundation preceded the monks' arrival

at the mountain. The monks planned thirty-two chapels as a fitting shrine to St. Francis; twenty were completed, most by the end of the seventeenth century. Since the chapels dedicated to St. Francis are numbered one through twenty, the chapel of Saint Nicola is the "zero" chapel.

Step through the stone archway at the Sacro Monte's entrance and walk into the life of St. Francis. On top of the arch is the saint himself, sculpted by one of the park's best artists, Dionigi Bussola. While the grim portrait well reflects the Franciscan vow of poverty, a happier demeanor might have better portrayed a man in love with all of life, and whose fellow brothers were known to frolic like children when spreading the gospel.

Internally, the Franciscan chapels are designed, painted, and furnished with sculptures arranged in strict chronological order. For example, the chapels begin St. Francis's life in clean lines, soft palettes, and almost cartoonlike frescoed figures, all appropriate to describing a birth and childhood. Externally, however, the chapels warp time and space. While numbered one through twenty, the first chapel to have had its corner-stone laid in commemoration of St. Francis is actually the last in number, XX.

Not only were chapels I through XX not built in strict chronological order, but they also differ in architectural style, sometimes even within the same chapel, reflecting the Monte's time line. For example, Ortesian artisans erected Chapel I in 1592. A Victorian architect, Paolo Rivolta, added its facade in 1849. Italy was then facing defeat in the nationalist revolutions that started in Palermo and ricocheted quickly to Paris and Vienna, ending in May 1849 in Dresden. The chapel's exterior is that of a country bent on self-government. Its shell and the interior, however, grew out of a province and not a

nation. In the late sixteenth century, "Italy" existed only as a jigsaw puzzle of autonomous duchies subject to their dukes, to the pope, to foreign invaders, and to the Holy Roman Emperor. Buffeted among these forces, the founders of the Sacro Monte looked to the pope for guidance, and specifically to the dictates of the Council of Trent.

The Council of Trent convened in 1545 to answer Luther's accusations against modern Catholicism. In terms of art, the council agreed in 1563, during its twenty-fifth and last session, that sacred images should symbolize the saints and not seduce the uneducated into praying to them as pagan idols. While churches can represent Scripture and biblical stories, which is "expedient for the unlettered people," the representations must be educational and realistic. In no way should the portraits be fantastic or overdone, which could cause Dante's "lowly crowd" to mistake papier-mâché for God himself.

All twenty chapels are beautiful, some in their simplicity, others in the awe they inspire in their crowded compositions and in the raw amount of time, labor, and talent that went into them. May the ones you like best be open.

Chapel I:
The Birth of Saint Francis

Chapel I is the sixth to be designed after the bishops returned from the Council of Trent, yet it could pass for the first, and not only because it describes St. Francis's birth. The chapel's intimate gathering of figures, its graphically naive paintings, and its obvious message mirror precisely what the bishops concluded at Trent after almost twenty years of contemplation: In art, the simpler, the better.

Chapel I, Prestinari, *The Birth of St. Francis.*

Christened Giovanni Francesco Bernardone and called by his middle name, Francis was born between 1181 and 1182. The scene tells the Christlike myth that St. Francis's mother, who is sometimes even referred to as the Virgin, chose to give birth in the stable when an angel told her it would make her labor painless. St. Francis's wealthy father was away in France—hence the son's name—conducting business when his wife gave birth.

The sheer number of servants crowding around the infant's bed proves Francis's less-than-humble origins. The tableau depicts only women, which is particularly interesting considering the stage set by the Counter-Reformation. The scene reflects the new Catholic Church that Martin Luther was forcing to be kinder and gentler. Just as some think that John the Baptist, the first prophet in Judaism in four hundred years, was a harsh version of Christ, so can St. Francis be seen as the prophet whose prayers and sermons are imbued with all of Christ's most feminine attributes. In fact, Francis dreamt

of himself as a woman and is often called the Other Christ.

Assuming that the scene is to be read by illiterates, we should look more closely at the sculpted nursemaid, who is ready to suckle the newborn. At first glance, we might think her a simple wet nurse, except that she dresses her hair with jewelry and coils and her overskirt is intricately embroidered. If this is like Christ's birth, then in her finery and fancy head-dress the nursemaid must play the part of the Three Kings, offering milk rather than myrrh to the holy newborn.

In the chapel's watercolor-like fresco, the father, Signore Bernardone, sprouts beautiful wings, which he did little to deserve except in siring this most saintly of saints. When still a young dandy, Francis heard his first holy hallucination at St. Damian's, outside of Assisi. "Repair my house," the Christ on the cross commanded, "which you see is falling to ruin." Taking the request literally, Francis returned home, "relieved" his father of an expensive bolt of cloth, and sold it and the

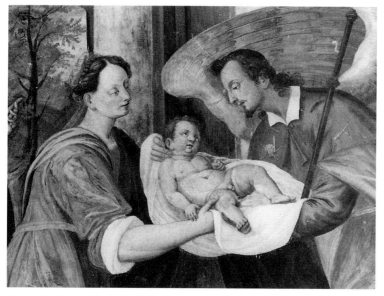

Chapel I, Monti, *The Birth of St. Francis.*

horse that he had ridden to Foligno. Returning to St. Damian's, he threw the coins at the feet of a confused and timid priest who refused to take the money. Signor Bernardone was furious, swore at his son when they met, and publicly humiliated and disinherited him. The experience helped lead Francis to find his métier in holy poverty.

Behind Chapel I lies the concentrated wealth of the villas that sit on San Giulio, like gems decorating a two-carat diamond. Here you often see a crane in the middle of the island carrying pianos to top floors or swinging statuary for the garden through the air rather than through the narrow streets. Saint Francis turned his back on all of that, choosing instead to sermonize to birds, his only feeling of embarrassment being that he had not thought of spreading the gospel to them earlier. With such an intensely caring nature, he would have never found happiness in taking over his father's business selling French silk.

Chapel X:
St. Francis Conquers the Devils of Temptation

Leaping ahead more than half a century, Chapel X celebrates St. Francis's victory over the devils of temptation. The scene captures St. Francis throwing himself naked into a thornbush, hoping to flay the devils out of his skin. Part of the sculptures' strikingly different aesthetic is that virtue is not the only vehicle for beauty; vice is also attractive in both face and body. The devils are not hunchbacks, with snaggleteeth and angular faces, as seen in the fresco by C. Francesco Nuvolone. The sculptures are instead the angels' worthy companions: square-jawed and full-lipped with deep, seductive eyes. They represent the dark side of the same coin from which virtue shines. Bussola is believed to have sculpted the scene in 1650. (In

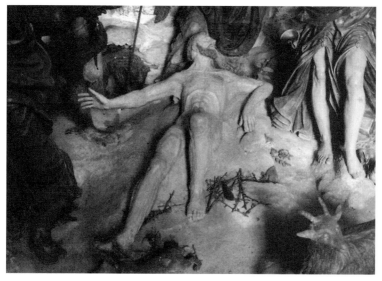

Chapel X, Bussola, *St. Francis Conquers the Devils of Temptation.*

1655, Antonio Pinti painted them.) If so, he demonstrates a deep understanding of how tempting temptations are.

St. Francis's drops of blood transformed the thornbush into a rosebush. Angels appeared and carried him to the Porziuncola, or "small portion," where he had a vision of the Madonna and Christ, illustrated in the eleventh chapel.

Chapel XI:
Jesus and Mary Concede the Indulgence for St. Francis in Ecstasy in the Porziuncola Chapel of Assisi

In the eleventh chapel, the Madonna asks St. Francis what wish she can grant. He asks that all who travel to the chapel of Porziuncola receive divine indulgences. She grants the request, as does Pope Honorius III, but only for a single day (August 2) each year.

The scene is of pivotal importance in the Catholic Church, for the other plenary indulgences are given in Jerusalem,

Rome, and Santiago de Compostela. If St. Francis had been a more political man, the significance of his power would have lured him from the path of humility. He competed with Jesus Christ himself in declaring his home to be sacred ground that cleanses sinners. Power and prestige did not tempt him, though. He accepted with gratitude the answer to his favorite prayer for the salvation of souls. On August 2, the pardon of Assisi still occurs, drawing thousands of supplicants to what was once a modest chapel. The sixteenth-century addition of the Basilica of St. Francis swallowed up the small portion in order to make room for the penitent.

Chapel XIII:
To Compensate for the Excesses of Carnival, St. Francis Walks Half-naked through the Streets of Assisi

In the sculpture of Chapel XIII, the Carnival celebrators ignore the half-naked St. Francis, insisting on enjoying themselves. They will not don pious ashes until absolutely necessary. His brothers lead him through the streets, as nervously protective as a pack of border collies hovering around a crippled lamb. To the left is the "Pervert of Orta": a bearded man dressed in a woman's gown; he flirts with a soldier-type who swats him away. While some might call the man a drag queen, he seems more like a typical Carnival reveler who turns day into night and is probably a traditional heterosexual pulling the leg of someone who knows him well enough to be rude.

Except for his brethren, only a couple of the celebrants heed St. Francis's humiliation as a call to repent. One man in the back is especially riveting: he not only clasps his hands in prayer but also seems to be either defending his right to piety

or barking at his neighbor to follow his lead and not wait until the last minute to step onto the righteous path.

Chapel XIV:
St. Francis Preaches to the Sultan of Egypt

The story displayed in Chapel XIV is a tribute both to St. Francis's charisma and to the verity of his biographer, Fra Bartolomeo of Pisa, a fourteenth-century Franciscan. St. Francis had traveled to Egypt to convert the "infidels" to Christianity. How can a man dressed like the poorest Umbrian peasant, with not even a leather belt to his name and little Arabic, be presented to the sultan of Egypt? The

Chapel XIII, Bosnati, *To Compensate for the Excesses of Carnival, St. Francis Walks Half-naked through the Streets of Assisi.*

leader of the portal to both Africa and the Middle East was a man of power, wealth, and very little time. In this triumph, as in his ability to gain an audience with and concession from Pope Honorius III, St. Francis transforms from myth to fact the rumor of his overpowering charisma. His eyes must have been truly black and filled with light, his voice compelling, his manner that of a great athlete or confident prophet. The power he felt from his God must have animated his step and handshake past every lackey that stood between him and the sultan. The terra-cotta figures make their importance known, such as the man with a ribbon of gold draped across his chest.

Though he gains an ear and a day, St. Francis did not convert the sultan. Brother Bartolomeo must have found his

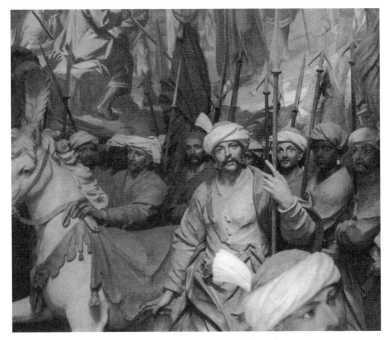

Chapel XIV, Beretta, *St. Francis Preaches to the Sultan of Egypt.*

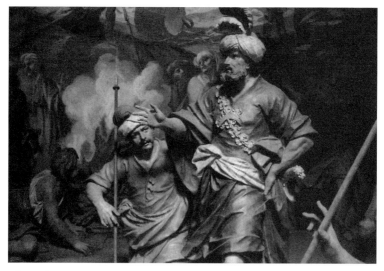

Chappel XIV, Beretta, *St. Francis Preaches to the Sultan of Egypt.* Note the fire blower in the back.

failure a difficult truth to reveal. How much easier to say that the sultan was impressed, knelt in prayer with St. Francis, and swore on the holy cross to turn Egypt, where Mary and Joseph fled with their newborn son, into a Christian nation. The failure to do so would have then been the Egyptian's and not St. Francis's.

The scene oddly reflects the one at the Vatican in Chapel XX, where again an international crowd of important men gather, but in Chapel XIV they are dressed in Arab turbans rather than cardinals' hats. In what is one of the most sophisticated statues, both symbolically and artistically, a servant blows on a glowing fire directly behind St. Francis. The figures of both Muslims and Franciscans are profoundly masculine and animated. The courtiers do not show the apathy of the Vatican Council. The exchange of words and ideas is obviously a true fight: the monks risk their lives to preach, and the Moors defend themselves with spears against the encroaching Westerners.

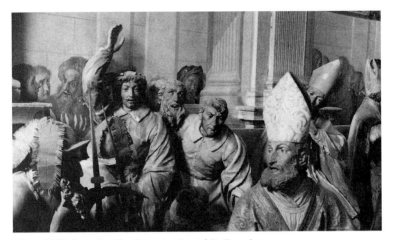

Chapel XX, Bussola, *The Canonization of St. Francis.*

Chapel XX:
The Canonization of St. Francis

Less than two years after he died, St. Francis was canonized by Pope Gregory IX on July 16, 1228. While the fresco assumes that the event set the heralds singing, as it might well have, Bussola's sculptural tabloid fascinates in its depiction of the cardinals' boredom, ignorance, self-obsession, pettiness, and cloud of white noise.

Bussola's message prefigures that of the giant Christmas tree at New York's Metropolitan Museum. Once a year, the Met dusts off its extensive collection of eighteenth-century Neapolitan crèche figures and arranges them in an unchanging display around and on a giant Christmas tree. At the base, in the front, the Messiah has been born, which interests the Holy Family and the menagerie. The Three Kings are on their way and appear eager to arrive. Otherwise, none of the other hundreds of peasants and shopkeepers in the *presepio* shows any curiosity about the birth, the angels that sing a full story above the Baby Jesus, or the comet streaming into a point at their heads.

So it is with St. Francis's sainthood.

Notice the artistry of Chapel XX's tromp l'oeil figures in the left back: the blind man whose eyes roll into his head and the shouting man striding away from the wall. They are in their own narcissistic worlds, as are the bishops and cardinals waiting to gain the pope's attention. In contrast, the fresco shows every cardinal and servant attending to and contemplating the Franciscan monk's impassioned words. The sculptures more accurately reflect St. Francis's desire in life. His spiritual home was a tiny rundown chapel below town. While the Mother Church swallowed up his Porziuncola with marble and gold, he preferred to die (Chapel XVII), naked and unshod, surrounded not by wealth and power but by those who loved him.

* * *

Other chapels that are especially known for their architectural beauty and should not be missed are Chapels VI, VII, XI, XIII, and XVII. If you have only five minutes to spare, the exterior of Chapel XV is considered the prize, an elegant and classical melding of Bramante's and Raphael's styles that sits in the woods like a baroque Pantheon.

Sacro Monte

Via Sacro Monte, 28026 Orta San Giulio

Hours: The chapels are open 9 A.M.–5:30 P.M. The park is always open. *Caution:* When it's raining, many of the chapels are closed to protect them from humidity.

Admission: Free

Telephone (for the nature reserve): 0322 911960

Fax: 0322 905654

Getting There: The trip to Orta should not be sandwiched in an hour on the rush from Milan to Zurich. Leave your car in the parking lot with the buses; Saint Francis is best met on foot.

From Milan, take the A8 highway northwest to A26. It is the second exit after Malpensa, and the exit immediately past Gallarate. Turn onto A26 and continue 24 km until the road divides into north and south branches. Take the north branch, following the signs that say To Arona. Get off at the first exit after the divide, turning southwest. Go 6 km to Borgomanero. At Borgomanero turn north onto S229. From there, you are about 13 km from Orta, which is the first town on the south end of the lake. You'll hit the town about 4 km after you start following the lake. The town, more properly known as Orta San Giulio, is on the east side of the lake.

By rail, go to the Orta-Miasino station, which is within walking distance of the Sacro Monte.

There's a bookshop at the bottom of the hill from Sacro Monte. A pleasant *pasticceria* is located down the main road; make a right at the bottom of the Sacro Monte path, turn left at the main intersection, walk about 100 yards, and you'll see the café on your right.

Venice

Gertrude Stein described her hometown of Oakland, California, as "There's no there there." In Venice (Italy, not California), there is plenty of there. Venice has so much there there that she is a natural refuge for those whose hometowns have decided there's too much "there" in them. The Jews of Genoa, for example, fled from the invading Austrians in 1508. In 1516, Venice created a "there" for them on a small island.

The Ghetto Nuova, or New Ghetto, was literally the world's first ghetto, the word coined from the Venetian dialect for a foundry that had long left the island, *geto.* The Italian *gettare* means "to cast," as in coins, but also "to hurl," "to fling," and "to thrust." The island's name unwittingly sums up the Jews' diaspora. It also branded their makeshift homes the world over as *ghettos,* which could reasonably be translated, mixing the Teutonic with the Italian, as "the Germans' castaways."

Lord Byron grasped the Venetian "there" in 1815 when he fled London, his wife, and their newborn child, Augusta Ada, who grew up to become the world's first published computer programmer. The poet had indiscreetly boasted of his affair with his half sister and the other daughter, obviously illegitimate, it produced. Where to go when all society turns its back on you in disgust? To the Grand Canal, where Byron hid his limp in Herculean swimming races and exercised his proclivity for women, once both before and after swimming four hours from the Lido to the Rialto Bridge. While "having" over two hundred women during his Venetian stay, a catalog second only to Mozart's Don

Giovanni, he lived with a mistress and her husband. Such a *ménage à trois* was already a centuries-old tradition in the Serenissima. The excess of sex and food turned Byron fat, pasty, irritable, and un-a-Mused—he found he could not write. The romantic vapors that rise from the Venetian canals like a veil and wrap themselves around every church and *ca'* left him numb, stumped as to how to complete the most romantic of poems, *Childe Harold*. He escaped all Venice's "thereness" by exiling himself to Geneva, where he found he could write in peace.

Richard Wagner had the opposite experience in composing his monumental opera *Tristan und Isolde*. In August

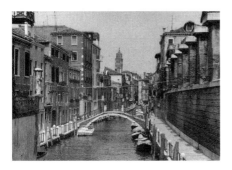

1858 he fled Switzerland for the Grand Canal. He had begun an affair the year before with his patron's wife, Mathilde Wessendonk. He could not have been less discreet, for he was living with his own wife, Minna, in a house in Zurich that Mathilde's husband, Otto Wessendonk, had built specifically for the opera composer's respite. Wessendonk had even put it on his own property, which meant his wife did not have far to walk when visiting Wagner.

The tiny gossiping Swiss city had been Wagner's final refuge from the German states. If he returned to his hometown of Dresden, he would immediately be arrested for revolutionary activities and treason. Never a natural linguist, Wagner had with this last of many excesses closed his escape route to all German-speaking countries. He could go to either Paris or London, the only cities outside of Germany with

opera houses that could feasibly support him. Irrationally, he went instead to Venice, with no income—Otto's money having inevitably dried up—and a voracious appetite for luxury. He somehow convinced the landlord to rent him an apartment in the stately Palazzo Giuliani. Here Venice's romance oozed from his pen in "a gentle brook" of newly composed sheet music. A gondolier's primitive cry inspired the melancholic English horn in the last act of *Tristan und Isolde*, which Wagner completed as the apex of romantic music, in the most quixotic of cities.

The city's "thereness" is outside, not inside. Touring Venice means wandering half the day outside, getting lost and discovering an instinct for understanding the sun's position in relation to St. Mark's, to which all streets eventually meander. One senses that only boring people hole up inside and work. Wagner himself indulged in daily gondola rides and nightly promenades, despite his publishers' impatience for him to complete the score they had already begun engraving. Victorian writers hint that "connections," as they called illicit sexual activities, occurred as often in alleys as in sumptuous apartments. Inside, one was the contessa, the milkmaid, the cavalier, the tutor, or the wet nurse. Outside, with a mask on, the milkmaid was the contessa, and with a gender-hiding *battuto* (baggy costume) and the shrill voice that by protocol accompanied a *gnaghe* (female-impersonating mask), the tutor was the wet nurse.

Sound lively? But that was in Venice's heyday, during the

sixteenth and seventeenth centuries. Now she is in her decay, as any guidebook or travel article will quickly inform you. And "now" has been a long time.

> *Venice, the eldest child of Liberty.*
> *She was a maiden City, bright and free;*
> *No guild seduced, no force could violate;*
> *And, when she took unto herself a Mate,*
> *She must espouse the everlasting Sea.*
> *And what if she had seen those glories fade,*
> *Those titles vanish, and that strength decay;*
> *Yet shall some tribute of regret be paid*
> *When her long life hath reached its final day:*
> *Men are we, and must grieve when even the Shade*
> *Of what which once was great is passed away.*
>
> —William Wordsworth,
> "On the Extinction of the Venetian Republic"

Wordsworth wrote these words in 1807. He was not spreading exaggerated rumors of Venice's death. Napoleon declared war on the marooned city on May 1, 1797, and by

May 12 had won the right to demand that her government, established for almost half a millennium, reform itself. He threw away the economy's linchpins, declaring medieval—with an emphasis on "evil"— the guilds that employed workers, protected them from poverty in sickness, paid their pensions, and supported their widows. Le Petit Corporal also dismantled convents, from which the ruling class, through its nun daughters, borrowed or embezzled

money to cover its gambling losses. Napoleon just about stripped the city in eight months—the Louvre should really be renamed the Venetians'—before handing her lovely head to Austria.

Yes, the Venice that Wordsworth visited was definitely on the list of soon-to-be-extinct cities, and had been for almost two hundred years. In 1630, the plague threw Venice's salt—a profitable monopoly—into the wounds of a decade-long economic crisis. And Venice had barely recuperated from her first plague, in 1348, which cost her half her population. She has been on the critical list ever since.

In other words, if Venice's death throes have been long, so has her wake.

Irony aside, the city's current suffering should not be diminished. The twentieth-century landfills alone, created for the modern conveniences of deepening shipping canals and creating an airport, have set the tides' ebbs and flows in disarray and exposed Venice's foundations. Her wooden piles stand in full view like over-periodontisted gums and reveal roots never meant to feel oxygen.

Byron offers a compromise, written a decade after Wordsworth's death knell:

> *Her palaces are crumbling to the shore,*
> *And music meets not always now the ear:*
> *Those days are gone but Beauty still is here.*
> *States fall, arts fade but Nature doth not die,*
> *Nor yet forget how Venice once was dear,*
> *the Pleasant place of all festivity,*
> *The revel of the earth, the masque of Italy.*
>
> — Lord Byron, *Childe Harold*, 1817

All cities suffer, from something either as long-eroding as capitalism or as dramatic and quick-acting as Napoleon and the plague. While Venice still lives, Byron can be the model tourist as he swims her canals, which are unarguably immortal, giving no thought to time or fatigue or how eventually one must leave this great "there."

<center>* * *</center>

Venice has as many recommended walks as there are alleys. The chapters that follow outline a specific walk that touches on truly Venetian paintings to highlight the city's art history, while keeping you outside as much as possible.

The Accademia

Start out the morning inside the Gallerie dell'Accademia. The collection does not sacrifice quality for volume and can be viewed in a morning. The catalogue is excellent but unfortunately overlooks a native son, Carlo Crivelli (c. 1435–c. 1495). In fact, most guides to the Accademia entirely skip over his three paintings, *St. Jerome and St. Augustine, St. Roch* (unfortunately now in storage), and the mostly destroyed *Sts. Peter and Paul*. With Paris Bordone's stormy and oceanic *The Fisherman Presenting St. Mark's Ring to the Doge* in the same room, who can blame them? Writers can cram only so many words onto a page.

In general, books in English on Crivelli are few and slim, and they often open with an apology for treating this "not great" painter. Yet he elicits instant devotion in those who love Giotto and often becomes a favorite of those who take the time to get to know his work.

Most of Crivelli's painted panels are in the Italian Marches region, although a few are scattered in London, France, and the

United States. Crivelli left Venice soon after a short prison sentence to avoid gossip about his 1467 "outrage" against a neighbor. A sailor's wife had accused him of abducting and seducing her with such success that they lived together for a while. He was either ruthlessly charming or extraordinarily naive; his paintings favor either interpretation, as they show both sensuality and innocence.

Crivelli sought peace in the Marches, literally the backwaters of Italy's eastern coast, with no major cities, castles, cathedrals, or extremely wealthy artistic patrons. He never returned to his hometown, but he reminded viewers of his true identity as a Venetian-schooled artist by signing his paintings "Carlo Crivelli, Veneti."

From Padua, Crivelli adopted the local artists' passion for garlands of fruit and portraying downward-cast heads. Yet he only strayed into Renaissance naturalism and instead clung to Medievalism. His style owes much to his exile, which began in his mid-twenties or early thirties, and to his missing the influ-

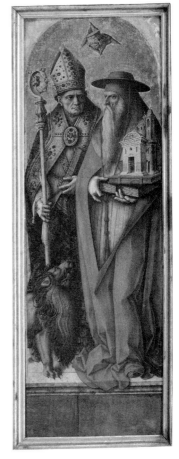

Crivelli, *Sts. Jerome and Augustine.*

ence of the brothers Bellini, Giovanni (c. 1426–1516) and Gentile (c. 1429–1507). They were about twenty years older than Crivelli, and they dominated Venice's art scene during his lifetime.

Unlike Crivelli, the Bellini brothers stopped painting with tempera on wooden panels made of poplar and instead experimented in painting on canvas with oil. Oil dries slowly and can be layered much more judiciously than tempera, yet it demands that the linen weave integrate itself into the picture as the smooth panels never did. The native sons used their

fecundity, their long lives, their brilliant technical and creative talents, and their sister's marriage to another great Renaissance painter, Andrea Mantegna, to give birth to a new medium in portraits and allegories. Their style lost the graphical precision that had defined all painting since the first cave drawings and gained more humanity than the filled-in cartoons of their contemporaries' fresco paintings. They fundamentally changed the look of Western painting after the fifteenth century. Yet Crivelli missed all of these changes. (To compare, look around Room XXIII at the various Bellinis, especially Giovanni's *Martyrdom of St. Mark*, which Vittore

Crivelli, *St. Roch* (in storage).

Belliniano finished for him, with its play of colors and light against shadows and water.)

What Crivelli practiced instead was the last vestiges of Late Gothic Fantasy. His graphical precision reminds one more of his German contemporary Dürer than of his *paesani*, or fellow citizens, whose work fills Room XXIII's other walls. In his *St. Jerome and St. Augustine*, the saints' fingers are elongated, pre-

cisely drawn, and exaggerated in their preciousness. The lion-as-kitten can appear in dreams, not in real life. The heads are huge, the bodies diminished, the perspective decidedly old-fashioned. Yet Crivelli can claim kinship with the Bellinis, and can call *"Paesano!"* from across the cavernous room. The three painters share the Venetian obsession with cloth and its color.

In examining the two saints' clothing, the patterns are intricately detailed, the brilliant red riveting. Both Bellinis occasionally unravel a bolt of silk to act as a backdrop to their figures, as Crivelli also highlighted a few of his Madonnas. But the brothers experimented in differentiating how a red silk cap shines above a duller, darker red in cotton tights. For Crivelli, red stays red, whether on a hat or a cloak or a lion's tongue or a book. (And he surpasses all artists when he concentrates his detailed eye on a book's folios, as one also sees in the *Sts. Peter and Paul,* or renders an animal's mouth or a flower in final bloom.) His is a Venetian red, a red still found in the depths of contemporary Venetian glassblowers' jewelry. Crivelli could not join the Venetian cult of experimenting with hues, yet can we call him the poorer for it?

Gallerie dell'Accademia

Hours: Tuesday through Friday 8:15 A.M.–7:15 P.M. and Monday 8:15 A.M.–2 P.M.; closed Christmas, New Year's Day, and May 1.

Telephone: 39 041 522 2247 or 521 2709

Admission: L 12,000; L 6,000 for ages 10–25; free for under 10 and over 65.

Getting There: Many *vaporetti* stop at the Accademia station.

The Peggy Guggenheim Collection

With its sculpture garden and terrace restaurant, the Peggy Guggenheim Collection transitions between outside and in. Its small collection is the second most visited museum in the city (the Accademia is the first). If you're not on a tight budget, have lunch at the Guggenheim restaurant and watch the Grand Canal float by.

The Guggenheim catalogue has always been first-rate in providing a detailed and lengthy tour of the museum. If you'd like to acquaint yourself with Peggy, who made her home in the museum for thirty-two years and personally hand-selected each piece, then her autobiography, *Out of This Century*, which the museum sells, is a must-buy and *Anti-Pope* by Max Ernst (1891–1976) a must-see. Ernst painted *Anti-Pope* from December 1941 through March 1942, during the honeymoon period of his marriage to Peggy. In *Out of This Century*, she mentions how she and her daughter populated his original small study for the painting, which is also now in the Guggenheim collection. He altered the figures in the large and final version on display in the Surrealist Room.

Most scholars interpret the painting as follows: the horse/owl woman on the left represents the painter Leonora Carrington, Ernst's lover before Peggy and his eternal beloved. Her owl head makes her figure recognizable, for she bears it also in the Guggenheim's *The Attirement of the Bride*. In addition, Carrington was very much a part of Ernst's life while he painted *Anti-Pope* and spent long hours walking the streets of New York City with him. She left for Mexico soon after Ernst completed the work.

The spear that divides the canvas represents Ernst's and

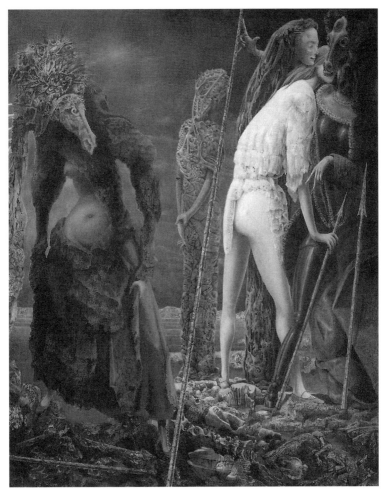

Ernst, *Anti-Pope*, symbolizing the complicated geometry among the artist, his wife, her daughter, and his lover.

Carrington's permanent separation. The horse on the right symbolizes Ernst. The pink figure in the middle with the armature of a horse's head and body that faces over the lagoon is Peggy's daughter, Pegeen Vail. In real life, Pegeen was like Alice in Wonderland: with her cascade of blond hair and petite figure, she lived as an eternally little girl who spent

too long traveling down a deep well and found herself the companion of surreal characters who spoke in epigrams. She finally married the Mad Hatter, Ralph Rumney, a New Expressionist painter. Their life circulated around drugs and booze until Pegeen overdosed on both and died of what many assumed was a suicide.

Yet according to Ernst's son Jimmy, the figure on the left is not Carrington but, as in the original study, Peggy. "I can tell by the awkward stance," he wrote in *Peggy Guggenheim and Her Friends*. Jimmy was also Peggy's secretary and confidant in New York when the brittle triangle of Carrington/Guggenheim/Ernst imploded. Peggy told him that she disliked the "monster" heads Ernst put on her and Pegeen. If his interpretation is accurate, then the figure in pink tulle on the right must be Carrington, separated by geography but never from Ernst's love. The spear must represent Peggy's inability to enter Ernst's psyche's inner circle. His marriage to Peggy, with whom he was never faithful and barely affectionate, lasted only four years.

Born in 1898, Marguerite Guggenheim, more familiarly known as Peggy, did not consider herself "a real Guggenheim" because she did not inherit the wealth equated with the name. Her father, Benjamin, died in 1912 with the sinking of the *Titanic*. It became an apt metaphor for what he did with his portion of the family fortune. After his brothers hustled Benjamin's bejeweled blond mistress out of New York (she had joined the cruise as "Mrs. Guggenheim"), they informed his widow that she was, in their terms, broke. Benjamin Guggenheim had split with the Guggenheim copper mining operation years ago and had forfeited almost eight million pretax, prewar dollars. What he had he sank into International Steampump, which was nearly bankrupt. The real Mrs.

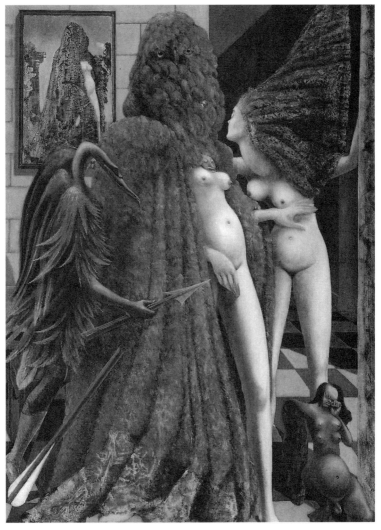

Ernst, *The Attirement of the Bride*, symbolizing the artist's lover and muse, Leonora Carrington.

Guggenheim inherited less than a million dollars, while her three daughters inherited $450,000 each.

But as the age-old saying goes, money is not everything. Despite her reduced circumstances, which forced her family

to leave its mansion next door to the Rockefellers and to cut staff, Peggy Guggenheim ended up collecting works by most of the twentieth century's great artists. She personally supported and promoted Jackson Pollock and Djuna Barnes, among many others.

Granted, Peggy bought at distressed prices. The surrealist and abstract artists knew their works would never survive the Nazis' abhorrence for "decadent art." While in Paris on the eve of the Battle of France in 1939–1940, Peggy bought a Brancusi bird sculpture, Giacometti's *Woman with Her Throat Cut*, Braque's *The Waltz*, and, on the very day Hitler walked into Norway, Léger's *Men in the City*. Her chutzpah astonished the artist, especially since the Nazis could have deported Peggy herself to a concentration camp.

Peggy's last-minute collection barely survived the German invasion of Paris. She covertly housed it in many places, from a barn to a museum, while arranging travel plans and visas for her ex-husband, his new wife, both couples' children, her lover . . . Peggy's usual menagerie. Finally, someone had the brilliant idea to ship the paintings to the States as "household linens." Canvas is, after all, made of linen, and it can furnish a home, so the truth was not stretched beyond its normal elastic boundaries.

The collection arrived in New York in the summer of 1941, as did Peggy and her entourage, which included her future husband, Max Ernst. In New York she entered the boxing ring with her uncle Solomon of *the* Guggenheim and began competing with his millions for contemporary art. Actually, Solomon's mistress, the baroness Hilla Rebay von Ehrenweisen, was Peggy's direct adversary as a collector. In 1937 the German baroness had opened the Museum of Non-Objective Art, which later bore the name of its true founder,

Solomon Guggenheim. The baroness accused Peggy of riding on "our fame"—hers and Solomon's—as an art collector and strong-armed realtors into not renting gallery space to Peggy.

Having just saved her collection from an entire German army, the *arriviste* from Paris had no intentions of allowing a mere von baroness to stop her. Peggy finally made do by renovating two tailor shops into an ingenious space for the Art in This Century Gallery, which launched many Americans and Europeans into the New York art scene. She gave Jackson Pollock (1912–56) his first one-man show in the late forties. Marcel Duchamp (1887–1968) was one of her mentors in selecting art, as was the English art critic, scholar, and poet Herbert Read.

Her friends have been especially quick to attribute Peggy's success to her guides, from her first husband to her last, and all her lovers, who read like a "Who's Who of Artists" in World War II: Constantin Brancusi (1876–1957), Duchamp, Ernst, and even Samuel Beckett (1906–89). But money talks. Peggy was the one who spent as much on paintings and sculptures in a year as she did on each of her grown children. She dedicated her life and fortune to promoting living artists, smuggling their works out and then back into Europe, paying the rent at that crucial time when an artist is catching the public's fancy but not its finances. This is especially true of Jackson Pollock, who until the fifties sold everything he painted to Peggy.

While in New York, Peggy published *Out of This Century,* which documents her love affairs like a French farce. She invented paper-thin pseudonyms that only highlight the culprits. Wives discovered their husbands' liaisons with her when they bought a copy. As the *New York World-Telegram* predicted, "A lot of men mentioned in it will wish they were disguised as non-objective art." An apocryphal story has her

wealthy uncles attempting to buy the entire printing. Ernst and his new lover and future wife, the painter Deborah Tanning, fled to Arizona rather than face the gossip excited by the pen of a woman scorned.

The New York gallery, though a huge success socially and culturally, failed financially. Peggy decided to move to Venice, which shocked her New York crowd. For them, someone whose openings were known to be the most exciting in New York had made an incomprehensible move to a backwater. There was no "there" there.

Peggy's motivations for the move in fact are not clear. She felt more comfortable in Europe, wanted to recuperate from her disastrous marriage with Ernst, which was her last, and, finally, had decided to keep her collection and not make a living by selling it. Though real estate prices in Venice have never been low, the city was ultimately cheaper to live in than New York.

Peggy struggled for four years with getting the collection into Venice and then keeping it there without paying outrageous tariffs. Finally, by touring the entire collection in 1951 in Amsterdam, Brussels, and Zurich and sneaking it through the Italian Alps via "very stupid, sleepy *douaniers*, who didn't know what it was all about," she made her collection official with a mere $1,000. Soon after, she opened the Palazzo di Venier, its single story earning it the name the "unfinished palazzo," to visitors three afternoons a week. She instructed her personal guests to lock themselves in their bedrooms rather than "streak" the tourists in the hallways.

Peggy's guestbook catalogs the great contemporary artists, intellectuals, politicians, and writers of her Venetian period. Truman Capote showed up one afternoon unannounced and shod only in slippers. The two gadabouts took to each other immediately and passionately, to the point where he stayed for two months and threatened to marry this woman twenty-six

Peggy Guggenheim riding through Venice in her custom-made gondola with her son, Sinbad Vail.

years older than he and altogether not to his orientation. In her life, Peggy befriended the gamut of twentieth-century figures, from the anarchist Emma Goldman, for whom she bought a house, to the singer/performance artist Yoko Ono, pre-Lennon, with whom she shared a room in Tokyo and giggled as the married Ono snuck in her lover. Peggy lent Berenice Abbott the money for her second camera and served as muse to Man Ray as a photographer, Virgil Thomson as a composer (who named a sonata *Guggenheim Jeune* after her London gallery), and Mary McCarthy as a writer. In Venice, she was what made a trip to the city necessary to complete her contemporaries' Grand Tour. Before treading St. Mark's stone mosaic floors in the footsteps of a millennium of visitors, friends and might-be acquaintances made a pilgrimage to Peggy's altar of new art.

In 1969, at the age of seventy, Peggy returned from Venice to New York as a prodigal niece. She allowed herself to be

wooed, as she said, by the suitor whom she was desperate to marry for seven more years before giving her collection to the Solomon Guggenheim Foundation. Immediately upon her death, her house in Venice metamorphosed into a museum. To conserve the collection the curator, Thomas Messer, eradicated, intentionally or not, her life. The Palazzo di Venier no longer acts as a cynosure for artists, the collection no longer belongs to an individual, and the museum reveals little of the woman who chose the artwork. The museum opened so quickly after her death that it served as her wake, which was conducted not by family but by Messer, who did not ask her only living child, Sinbad Vail, to speak.

The museum allows visitors to Venice to say something original once again. In fact, Mary McCarthy, who complained that everything about Venice had already been said, created a character, meanly named Miss Grabbe, based on Peggy in "The Cicerone," which appeared in her collection *Cast a Cold Eye*. Her portrait of the "last Dogaressa" is merciless, and yet not original. Peggy has been accused more than once of being miserly, often by those whom she supported for years, and sexually promiscuous. Of course she might never have founded a museum if she had not been aggressive, even to the point of being heartless toward her children, fawning her love instead on her Lhasa apsos, with whom her ashes rest in the museum's garden. True, when her only daughter, Pegeen Vail, committed suicide in 1967, Peggy stopped dyeing her hair jet black and set up a shrine to display Pegeen's paintings, but the tragedy failed to soften her maternal heart enough to will her son Sinbad Vail even a single painting, or to request to be buried near him and his children.

What Peggy did leave upon her death on December 23, 1979, cannot be dismissed as a legacy of avarice and vanity.

Her collection includes early works by most of the first half of the twentieth-century's great artists, and a space for them in one of the world's most beautiful cities. She lived up to her name in her sexual appetites, in her concern for copper pennies that add up to dollars, and in her wish to preserve American culture at a great moment for future generations. Her initial investment of $40,000 was at her death estimated to have risen by another three zeros. Even with relatively shallow pockets, she proved to be a genuine Guggenheim.

The Peggy Guggenheim Collection

Calle del Cristoforo

Hours: 11 A.M.–6 P.M.; Saturday 11 A.M.–9 P.M.; closed Tuesday. Some years it is closed for renovations January 6–February 1.

Admission: L 12,000; L 8,000 for university students and children under 11.

Telephone: 041 520 6288

Fax: 041 520 6885

Getting There: When leaving the Accademia, turn right, then right again at Rio Terra Foscarini di Sant'Agnese. Take your first right onto Calle Nuova S. Agnese and continue straight past the Cini Collection of Tuscan paintings, Campo di S. Vio, and St. George's Church until you are on the Fondamenta Venier and standing in front of the famous stained-glass-sprinkled iron gates that lead into the Palazzo di Venier dei Leoni.

In the summer, there is a second entrance to the museum on the Fondamenta Venier dei Leoni, number 708.

Santa Maria della Salute

Venice promised the Virgin Mary a church if she stopped the plague that killed a third of the city's population in October 1630; it was over in weeks. Santa Maria della Salute's first Istrian block—the stone that is pumiced, polished, and sometimes painted to resemble marble, giving Venice its definitive white—was set as its cornerstone in 1631. La Salute's creator, the thirty-two-year-old architect Baldassare Longhena, died

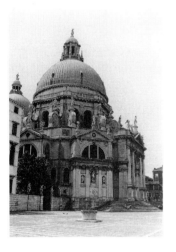

at eighty-three: old, yes, but not old enough to see the church completed, which took another five years.

Except for the baroque scrolls, or "earrings," and the floor plan, which are vaguely Byzantine, the facade and interior are entirely Italian and yet also entirely original. Though the dome is like St. Peter's, Longhena's other architectural details are typical neither of the period—the best-known building of the year is the modest hunting lodge known as Versailles—nor of what came immediately after it, for no one imitated the young Venetian maverick's Palladian arches and octagonal layout.

Longhena designed the building to be exactly what Venice saw when it opened (still incomplete) in 1681: the city's Big Earring, the sparkle that catches the eye no matter where one stands. The site gives an unobstructed view of Venice worthy of Canaletto and was chosen specifically because it faced both San Giorgio Maggiore, which from the front steps lies straight ahead, and the Zitelle, to the right,

and was halfway between Il Rendentore, ninety degrees to the right, and San Marco, to the left.

The church was built specifically for the single ceremony that commemorates the Virgin's mercy on La Serenissima. Every November 21 from 1687 until Napoleon defeated Venice, the doge walked across a temporary wooden bridge that is still built annually across the Grand Canal to La Salute. *Salute* means "health" but also "welfare," as in "*salute pubblica.*" The doge and his entourage entered, sat in assigned seats, heard low mass—high being always reserved for St. Mark's—and left. For this single event the floor was laid out, the high altar presented with a singular view, the entrance made of triumphant arches that are never seen as they should be except on the one day per year. As Thorstein Veblen would say, that is conspicuous consumption.

Even in the new millennium, the entire city gathers on November 21 to honor the Virgin's seventeenth-century intervention. The liturgy also murmurs thanks to the plague victims' more terrestrial bedside angels: the doctors who stayed in Venice when everyone who could deserted the city. Rather than fleeing, they tended the sick while wearing prophylactic masks and waxed cloaks, which made them feel invulnerable but did nothing to protect them from the bites of leaping fleas or from patients' contagious coughs.

In the back of the church the sacristy charges L 3,000 to see Titian's tribute to the plague healers in his stunning *St. Mark with Saints Como and Damian, Roch, and Sebastian.* Tiziano Vecellio (born c. 1485, died 1576 during the first plague) followed closely on the Bellini brothers' heels in experimenting with color and texture. His technique is to this day considered miraculous: first he painted huge blocks of color—red, lead white, gray, and black—then turned the

Titian, *David Conquers Goliath*, a reminder of how plague-carrying fleas crushed proud Venice.

canvas to the wall. Weeks later, he faced it forward again and removed what was extraneous to his super-critical eye. He added and subtracted layers until his brushes became too objective for his work, after which he dabbed and smeared paint with his fingers.

Titian chose the four saints to symbolize healing. The miraculous cures of the twins Saint Como and Saint Damian earned them their early position in the hagiography. St. Roch (or Rock) healed multitudes of the plague in the fourteenth

century; his dog healed him, which explains why a canine identifies him in many portraits. Finally, Renaissance artists' most-likely-to-be-painted saint, Sebastian, survived his arrow wounds thanks to the ministrations of the widow of another saint, Castulus.

The other Titian works in the sacristy also personify the Venetian victory against the plague, even though they were not part of La Salute's design, having been brought in from another, suppressed church. *David and Goliath* illustrates how the tiny can kill giants; *Abraham and Isaac* reflects how the Venetians must have felt like Isaac after the plague left so quickly; *Cain and Abel* shows that when one thrives, another must die.

The sacristy is a cozy niche in which to sit and contemplate all the paintings, such as *Marriage at Cana* by Tintoretto (1518–94; born Jacopo Robusti and nicknamed after his father the dyer), which is a study of his facile dramatization of space and a multi-portrait of his contemporary bohemian crowd. Many consider it to be the church's prize. Also by the altar is *Madonna with Angels* by Padovanino (1588–1648; christened Alessandro Vartori).

Basilica di Santa Maria della Salute

Fondamenta della Salute, Dorsoduro

Hours: 9 A.M.–noon and 3–6 P.M.

Sacristry Admission: L 3,000

Getting There: Upon leaving the Peggy Guggenheim Museum, turn right and walk straight until you run into Santa Maria della Salute.

Santa Maria del Rosario

Leaving La Salute, to your right (this whole itinerary circles to the right) is the customs point that sports Fortune balancing a ball. In the early history of continental trade, those transporting goods East to West had to pass through the needle's eye called Venice. In the fifteenth century the city established the Dogana di Mare to augment its sea-based tariff-collecting operation. Like Santa Maria della Salute, the Dogana offers one of the best views in Venice of the opulent palazzos and San Marco's on the left, and La Giudecca and Isola di San Giorgio Maggiore on the right.

Continuing right, you are now on the Fondamenta delle Zattere, named after the floating rafts that carried the lumber and spars that could be brought only to this port. You will pass L'Ospidale degli Incurabili, the church hospital at St. Agnese named after its first syphilitic patients. It was turned into an orphanage shortly afterward, during the sixteenth century, and was also used as a music conservatory. Every Sunday the chapel conductor would have written a new piece and practiced it with an ensemble of orphaned girls. In the 1680s the Incurabili and the other hospitals were the sole venues for the relatively new art form of oratorio. Until recently the Incurabili was a children's home and educational institute. Today, sadly, the hospital is silent and usually closed, and one no longer hears seeping through the thick-paned windows the sound of passionate teenage girls giving their all to rapid violin arpeggios and somber clarinet bass lines.

Once you cross the Rio delle Torreselle and the Rio di San Vio canals, the first church you come to, Chiesa dei Gesuati, boasts a ceiling full of Tiepolos.

Some sources might identify the Chiesa dei Gesuati as the "Visitazione." Will the real Santa Maria della Visitazione please stand up? Visitazione is actually farther along the Zattere, despite what you might have read to make you think it is the church with the Tiepolos. In Italy, one does not definitively say, "My name is Michele." One can say only that "I am called Michele," or, for *La Bohème* fans, "Mi chiamano Mimi"; "They call me Mimi." The church with the paintings by Giambattista Tiepolo (1696–1770) is the Church of the Jesuits, also known as Santa Maria del Rosario. What they often call it, though, is Santa Maria della Visitazione—"they" being, for example, the World Monuments Fund and many Web sites.

The confusion stems from Venice's Council of Ten kicking the Jesuits out of what was the church of the Santa Maria della Visitazione and all of Venice in 1606–07. They did not return to the city until 1657. By that time the Dominicans had changed the church's name from Santa Maria della Visitazione to "of the Rosary." The paintings by Tiepolo attest to the change, depicting St. Dominic and his evangelizing the use of the rosary in prayer. Even when named correctly, the church's priests are called the Gesuati Dominicans, a nomenclature that boggles the Protestant mind.

The Chiesa dei Gesuati should receive an award for Friendliest Church to Art Lovers. They have installed huge mirrors to assist visitors in peering up at the Tiepolo ceiling, and they describe and label everything in sight, making all works extremely accessible in terms of viewing and appreciating them.

Tiepolo's *St. Dominic Distributing the Rosary* uses a cascading staircase, ballooning clouds, the corner of a Greek temple that is a Venetian building, and a clever banister

and . . . sewer, perhaps, at the bottom, to add to the painting's depth and interest. Tiepolo began the fresco that illustrates St. Dominic's life in 1738 and ended it in 1739 just in time for the Feast of the Rosary on October 7. Assuming that you are looking up and not at the mirror, on the center right St. Dominic distributes the rosary to rich and poor alike. Notice the doge, who represents Venice and hints that Our Lady gave Dominic the rosary in Venice. Also in the crowd are peasants, a pope, an Asian, and Tiepolo himself, on the extreme right, looking down. Below, in the sewer, are the demons of heresy whom the rosary has evicted into the streets of eternal damnation.

A pair of men lie to the bottom left, touching hands. While the halberdier dangles his foot over the windowsill, a nude Mannerist figure turns his back to us. He is not in the Tiepolo style: the artist draws his muscles too precisely and depends heavily on chiaroscuro rather than his usual shades of tangerine, lemon, and sky blue. The nude's arms contrast in bold muscularity with the soldier's flabby and bony legs, which his bagging gray tights fail to disguise.

The soldier does serve a compositional purpose in pointing his halberd directly to the rosary, which could otherwise get lost in the riot of color and narrative. However, as art historians have pointed out, he could well be a tribute to Paolo Veronese (1528–88) and a symbol of the Inquisition the Venetian painter faced down. These entirely ornamental figures would have irritated the Inquisitors, who had asked Veronese why he insisted on placing characters extraneous to the story in his depiction of The Last Supper, which hangs in Venice's Accademia. Clinching the connection is the nude figure to the soldier's left, which is more from Veronese's than Tiepolo's brush.

Tiepolo, *St. Dominic Distributes the Rosary.* Note the halberdier at the bottom of the stairs lounging with the Mannerist-style nude, a tribute to the painter Veronese's courage in front of the Inquisition.

Santa Maria del Rosario, or Chiesa dei Gesuati
Hours: Monday–Saturday, 9 A.M.–6 P.M.; Sunday 1–6 P.M.
Telephone: 04 2702411

Getting There: Upon leaving La Salute, turn right onto
the Fondamenta delle Zattere. After crossing the Rio
delle Torreselle and the Rio di San Vio canals, Santa
Maria del Rosario is on your right.

Santa Maria della Visitazione

When the Dominicans took over what is today Santa Maria
della Visitazione from the Jesuits in 1668, they turned it into
a library. It has been a church again since 1825. Venice in
Peril as well as some Australian and British organizations have
all contributed to its 1990s restoration.

On the outside of the new Jesuit church, a lion's mouth
gapes open, placed there by the Council of Ten, which ran

Venice until Napoleon reformed the
government. The lion's inscription
claims to be the place for complaints
against littering and polluting, yet it
seems more ominous when mounted
in front of the order that the council
had closed down. Could the lion also
encourage complaints against the
priests who, as confessors, had access
to too many state secrets? The Council
of Ten was constantly vigilant against all Catholic orders
that were not Venetian and that instead allied themselves
with Rome.

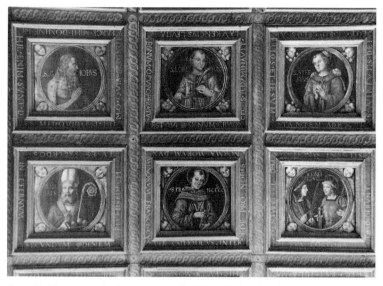

Agapiti: Martyrs and saints portrayed with Umbrian simplicity and plainness.

Walk in. Glance around the warm and intimate interior. Feel at home. You've been on your feet for a while: lie down.

That's right. If no one is tending the church, lie down on one of the benches with your feet hanging over the edge and stare at the wooden ceiling at your leisure. Umbrian artist Pietro Paolo Agapiti (c. 1470–1540) painted the fifty-eight saints, martyrs, and prophets. In the middle tile is a Visitation; the church is dedicated to the visit that the Virgin Mary paid to her cousin Elizabeth, mother of John the Baptist. Of all the art in Venice, these simple tiles from the Sassoferrato native could very well be the faces that follow you home.

Like Crivelli's figures, these are not beautiful in a contemporary sense, as are Tiepolo's saints and Madonnas, nor sophisticated like Titian's *Cain and Abel*. Their very nature as woodcuts makes them seem like craft instead of art. Their hominess, even homeliness, makes them accessible and credible. After all, do only beautiful people martyr themselves? La

Visitazione provides a more Catholic than artistic view of saints: they lie above us, gazing beatifically upon us mortals who throw ourselves supine in awe before the beauty of their self-sacrifice.

Santa Maria della Visitazione

Hours: 8:30 A.M.–noon and 3–6 P.M.; Saturday and
Sunday 3–6 P.M.

Getting There: Turn right onto the Zattere after leaving
the Chiesa dei Gesuati. Binoculars are recommended.

Caffè Florian

Walk to Piazza San Marco to have a coffee outside one of the oldest coffeehouses in Europe, Caffè Florian. Established in 1720, the café is a relative newcomer in Venetian history, espe-cially when compared with its neighbors, St. Mark's Basilica and the Palazzo Ducale, both founded in the ninth century. Yet Florian's has packed in its share of historical figures, including Charles Dickens, Giuseppe Verdi, Honoré de Balzac, Richard Wagner, Henry James, Marcel Proust, and Igor Stravinsky, just to name the more recent patrons. In *Massimilla Doni*, Balzac writes:

> The Caffè Florian at Venice is a quite undefinable institution. Merchants transact their business there, and lawyers meet to talk over their most dif-

ficult cases. Florian's is at once an Exchange, a green-room, a newspaper office, a club, a confessional,—and it is so well adapted to the needs of the place that some Venetian women never know what their husband's business may be, for, if they have a letter to write, they go to write it there.

Spies, of course, abound at Florian's; but their presence only sharpens Venetian wits, which may here exercise the discretion once so famous. A great many persons spend the whole day at Florian's; in fact, to some men Florian's is so much a matter of necessity, that between the acts of an opera they leave the ladies in their boxes and take a turn to hear what is going on there.

In modern terms, Florian's is the Internet, e-mail, and chat rooms all wrapped into a few tables. This is not, however, virtual reality. Plan to spend 100,000 lire on a simple lunch for two. If a band is playing, the involuntary ticket price is added to your bill.

Venice also hosted Europe's very first coffeehouse, the Bottega del Caffè, in 1683. The Bottega's owner probably thought of the idea in a visit to Constantinople, where coffeehouses were so popular the Grand Vizier banned them in 1600; anyone caught for a second time drinking coffee was drowned in the Bosporus. Cafés are just one of Venice's many benefits in being a portal to the East. Another is architecture, which you can appreciate as you gaze at St. Mark's Square, sip the extravagantly priced cup of espresso, and wonder at the mixture of domes and medieval architecture in the Basilica and the Doge's Palace.

Mark Twain found that "one is calm before St. Mark, one

is calm within it, one would be calm on top of it, calm in the cellar; for its details are masterfully ugly, no misplaced and impertinent beauties are intruded anywhere; and the consequent result is a grand harmonious whole, of soothing, entrancing, tranquilising, soul-satisfying ugliness. . . . I have not known any happier hours than those I daily spent in front of Florian's, looking across the Great Square at it. Propped on its long row of low thick-legged columns, its back knobbed with domes, it seemed like a vast warty bug taking a meditative walk" (*A Tramp Abroad*, 1880).

Caffè Florian

Piazza San Marco, 56

Hours: 10 A.M.–11:30 P.M. or midnight; open daily in
summer (15 March–31 October); closed Wednesday
in winter.

Telephone: 041 5205641

Fax: 041 5224409

E-mail: florian@venezia.it

Getting There: If coming from Santa Maria della
Visitazione, turn left onto the Zattere and take the first
left (immediately after Gesuati) onto Rio Terra Foscarini
di Sant'Agnese. Veer left and take the Ponte
del'Accademia across the Grand Canal. Walk into
Campo Santo Stefano and take Calle di Spezier on the
right, then continue east until you run into Piazza San
Marco. If coming from elsewhere, take a vaporetto to
S. Zaccaria. The café is across from the Doge's Palace.

Vittorio Costantini

Like doctors, glassmakers who excel in their field are friends with one another. Go to the shops with badly crafted glass insects, and they honestly have never heard of the master whom they imitate, Vittorio Costantini. The good shops do know him, though, and can direct you to his tiny shop on Calle del Fumo, 5311.

Costantini has been crafting his insects for over thirty years. He was born in 1944 on the pastel-painted island of Burano to a fisherman and a lacemaker. The self-contained universe of insects fascinated him at a young age; he remembers studying them along the shoreline. Since then, Costantini has been studying from a single nineteenth-century book on entomological anatomy, from which he has learned about the insects' twenty-one parts that he must weld together with a microsurgeon's care.

Costantini explores insects that raise the hackles of most humans for their garbage-, dung-, and corpse-eating habits. His are not only "pretty" insects, though each scorpion, grasshopper, and bee is wrought to please the eye. His flies are like beauty marks sprouting hair. His beetles are anatomically perfect and come in different species, from the big-horned *Aegosoma centaurus* to the lowly *Coccinella septempunctata*, or ladybug.

In appreciating the ugly for their beauty, the Burano glassmaker transcends craftsmanship into art. The Palazzo Grassi

and Palazzo Ducale in Venice both display his works, as do the Museum of Natural History in Bologna, the Corning Museum of Glass in New York State, the Museum of Venetian Art in Otara, Japan, and the Oceanographic Museum in Monaco. The museums as well as the international exhibits where he has held shows and the American and Japanese galleries that carry his work all value the dark underside to this work that Costantini makes light. His dragonflies, butterflies, seashells, fish, and birds allow those glass collectors with a more traditional sense of beauty to take home precious cargo. But it is Costantini's appreciation of the maligned masses that fascinates. His spirit in glass is like that of the seventeenth-century poet Kobayashi Issa's in his haiku:

Don't kill the fly,
It prays with its hands,
Its feet!

Bottega di Costantini

Calle del Fumo, 5311

Hours: 9:15 A.M.–1:00 P.M., 2:30–6:00 P.M.; closed
Saturday afternoon and Sunday.

Telephone/fax: 041 522 22 65

Getting There: Take a vaporetto to Fondamente Nuovo; the shop is on Calle del Fumo. Or: Take the Calle Cappello Nero out of Piazza San Marco straight through Calle Fabbri, which turns into Calle Bembo before you reach the Riva del Carbon. Turn right toward the Ponte di Rialto. Pass the bridge, then take your first right onto

Salizzada San Giovanni Grisostomo. Go straight, then turn right onto Salizzada San Canciano. Pass the San Canciano church and jog immediately right and then left onto Calle Widmann. Go straight, then bear diagonally left (north) through two squares to Calle del Fumo.

Caution: Packing and carrying the glass insects through the rest of Italy is onerous, especially if one of your pieces is the eight-gossamer-legged spider. When they are home, they are like snowflakes that will not melt and stay perpetually fragile and unique. Display them in boxes of cotton or, better yet, sand.

The Vaporetto

A more expanded view of Venice should be welcome after any morning spent contemplating art. One of the best deals and most interesting tours is a vaporetto ride around the city's canals and lagoons. While disembarking at certain islands to explore is fun, so is just staying on the motorboat. The trip can take an hour and a half or the entire day, depending on your mood.

Be warned that the vaporetti routes and numbers changed in 1999. Most guidebooks are outdated. An excellent place to find all routes and times is the ACTV Web site: www.actv.it/pre-servizi.html.

The following is one possible itinerary. If the kiosk is closed and you cannot buy a ticket, make sure to buy one from the vaporetto conductor immediately or risk paying a deep fine.

Start at the Zattere. Take the vaporetto N or 82 west to the
Ferrovia railroad station. Get off and take the 41 or 42 to the
Murano Museo. This Palazzo Giustiniani museum displays
the best work of what was once a ghetto of glassblowers. The
artisans were not allowed to leave the island for fear that they
would go elsewhere with their "corporate secrets" on how to
make exquisite jewelry, sculptures, and vases, and thus under-
mine Venice's monopoly on the world's best glass. The
Bohemians were especially aggressive about infiltrating the
island and her craft. The glass exhibit runs from a section on
glassblowing in ancient Rome, through the fifteenth-century
marvel Angelo Barovier's Bowl and the nineteenth-century
handblown chandeliers, up to the twenty-first century.

San Lazzaro, an Armenian monastery named after the
patron saint of lepers, provides another excellent getaway if
you have had your fill of the mainland, if you want to do
something separate from your teenagers, or if you need
something for the dull afternoon hours when everything
closes. Take the No. 20 vaporetto from San Zaccaria, near the
Piazza San Marco, at 2:50 P.M. It stops at San Servolo Island
and reaches San Lazzaro at 3:20 P.M. Byron visited this island
twice a week during a six-month period, which is recom-
mendation enough for spending seventy-five minutes on the
guided tour.

Another day's itinerary starts with looking at the
vaporetto map and seeing what boats are due soon. Decide to
make a couple of stops, and be sure to include the Lido,
if you're visiting in summer, to see the jet set.

More serious, Save Venice Inc., Venice in Peril, the World Monument Fund, and others in 1999 completed the restoration of the Jewish cemetery on the Lido, which dates to the sixteenth century. It is open Sunday or by special arrangement with the Jewish Museum of the Ghetto.

Next, go to Burano to see how many different colors you can spot in the whimsically painted houses—violet, green, blue, orange, yellow, and red—and to visit the lace museum. The Palazzo del Podestà rotates its antique laces, which date back to the fifteenth century, in order to preserve them from too much light. The nineteenth- and twentieth-century Burano laces are always on display.

Then visit Murano for a short shopping trip (though most of its best pieces are sent to the mainland). Finally, stop at San Michele to wander through the graveyard to visit old friends Stravinsky and Diaghilev.

The authentic native experience is boating in the middle of all that water. This is the Venetian world. Before the mid-nineteenth century, when the tourist trade started overwhelming the Venetians' everyday lives, these waters were their gold mine, with thick and rich and deep veins called piracy, fishing, trade, and port services. St. Mark's lurches too large in the tourist's eye, as does the entire mainland. The water is the true mainland, the foundation of the city, where the Venetians once lived from dawn to dawn.

To end your vaporetto rides at San Zaccaria, near St. Mark's, you can take the boats mentioned

above: N, 82, 41 and 42, and 20. Others that will also leave you at St. Mark's after some island-hopping are: 1 (Lido), 12 and 14 (an excellent tour: Murano Faro, Burano, Mazzorbo, Torcello, Treporti, P. ta Sabbioni), and 51 and 52 (Lido). Again, check maps and times when you arrive; even the Web site contradicts itself.

If you are still longing for water, gondolas are the boat for a perfect sunset cruise. For about L 200,000, you can discover what has inspired centuries of writers, poets, and composers. If with a paramour, you can kiss. If the gondolier shouts and rocks the boat, either curse or tip him.

Murano Museo

Isola di Murano, Fondamenta Giustinian, 8

Telephone: 041 739586

Hours: 10 A.M.–4 P.M. in winter; 10 A.M.–5 P.M. in
summer; closed Wednesday. The ticket window closes
half an hour before the museum.

Admission: L 8,000; L 5,000 for students and children

San Lazzaro Monastery

San Servolo Island

Hours: 3–5 P.M. for visitors

Admission: Tour fee of L 8,000

The Lace Museum

Isola di Burano, piazza Galuppi, 184

Telephone: 041 730034

Hours: 10 A.M.–4 P.M. from November to March;
10 A.M.–5 P.M. from April to October; closed Tuesday

Admission: L 8,000; L 5,000 in groups

The Jewish Museum (Museo Ebraico)

Cannaregio 2902/b, Campo del Ghetto Nuovo

Telephone: 041 715359

E-mail: museoebraico@codesscultura.it

Hours: 10 A.M.–7 P.M. from June 1 to September 30;
10 A.M.–5:30 P.M. from October 1 to May 31; closed
Saturday and during the Jewish festivities.

Admission: For just the museum: L 5,000; L 3,000 for
students and children. For the synagogue and
museum, L 12,000; L 9,000 for students and children.

In addition to the Jewish cemetery on the Lido, the Jewish Museum in the Ghetto Nuovo displays antique liturgical textiles and furnishings. To visit the synagogues, one must either attend services or join a guided tour. Tours in English begin half past the hour and last forty minutes; French and Italian tours are also available.

**Tours of the Jewish Ghetto schedule
(always subject to change):**
June through August: Sunday–Thursday,
10:30 A.M.–7:30 P.M., every hour on the half.
Friday, 10:30 A.M. until an hour before Shabbos.
Closed Saturday.
September through May: Monday–Friday,
10:30 A.M.–3:30 P.M. every hour on the half.
Closed Saturday and Sunday.

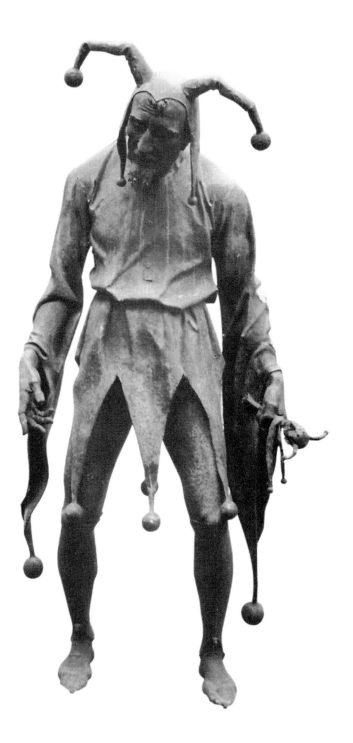

Mantua

Despite not possessing the wealth of Florence's Medicis or Milan's Sforzas, the Gonzaga family of Mantua created a city that deserves to be on the Grand Tour as a necessary stopover between Venice and Florence. An addiction to collecting and to satiating their superior appetites in art, architecture, and music dissipated the Gonzagas' wealth. It also fueled their power by establishing their reputations for three centuries as men and women of excellent taste and vast culture. Reputation was often all they had to barter with when they teetered between the powers—Milan and Venice, France and Spain, and the ubiquitous pope—in diplomacy, war, allegiance, and marriage contracts. An African saying warns, "When elephants fight, the grass suffers." By commissioning magnificent churches and startlingly modern frescoes, the Gonzagas could not be mistaken for grass.

What we know of Mantua's origins comes from its most famous native son, Virgil. Born in Andes near Mantua in 70 A.D., the poet claims that the city is named after an Etruscan god, Mantus, which the city's founder worshiped. He probably also sacrificed a few goats to Mantus's goddess companion in the nether lands, Mania.

A circle of water gives Mantua its quiet charm. In 1198, Alberto Pitentino diverted the Mincio River to make the city's surrounding lakes, not for their quiet or charm but as a defensive barrier. His gambit worked well. The lakes and their marshy periphery made Mantua almost invulnerable to outside attack and thus ensured its prosperity.

The Ducal Palace *(Reggia dei Gonzaga)*

Like Florence, Mantua's cultural significance owes much to the acumen of a single family. The Gonzaga clan ought to be as well known as the Medicis; Ludovico II and Isabella d'Este deserve the fame of Lorenzo the Great and Catherine di Medici. Originally feudal gentry, the Coradi family took Gonzaga as their name from a castle that lies between Mantua and Reggio. Between the rents they collected from peasants and the Catholic Church's good graces, the Gonzagas gradually extended their lands, wealth, and power.

In 1328, the Gonzagas challenged the Bonacolsi family, which had ruled Mantua for only fifty years, in a battle made famous by Domenico Morone's painting *La cacciata dei Bonacolsi,* which still hangs in the Ducal Palace. (Usually translated as *The Expulsion of the Bonacolsi,* the title should be rendered as *The Bonacolsi Hunt,* as in "fox hunt." It also accurately describes the battle's bloody finale.)

The Gonzagas did not actually take possession of the Ducal Palace until much later. The last Bonacolsi survivor, Ziliola, caused the long pause by refusing to concede the Gonzagas' claim. She stubbornly remained in the palace, which Guido Bonacolsi had built, until her death almost thirty years later. A mere woman thwarting the Gonzagas in their quest for power sounds like a fairy tale in the context of the rest of their story. Once they took control of Mantua in 1354, they held on to the reins with bloody fists for over three hundred years of alliances and battles.

Even during their most ambitious wars, however, the Gonzagas managed to collect art. Their passion for cultural accumulation, which extended to architecture and music,

The Ducal Palace (exhibition gallery), still resplendent despite the
Gonzagas' mining the collection to pay debts and the 1630 sack of Mantua.

passed from father to son. If the gene missed a generation, the
men reintroduced it by marrying women with sympathetic
ears for all the Muses.

As the first Gonzaga cultural patron, Guido (Marquis
1360–69) brought the early Renaissance poet Petrarch to his
court. But the Gonzaga most responsible for establishing the
Ducal Palace's greatness as a museum and Renaissance cul-
tural center is Ludovico II, the Marchese di Mantova, who
ruled from 1444 until his death in 1478 at the age of sixty-
five. Though his furor in battle earned him the nickname
Luigi the Turk, during his reign he surrounded himself with
great artists, including Donatello, Pisanello, Leon Battista
Alberti, Luca Fancelli, and Andrea Mantegna.

Under the marchese's rule, Alberti designed and began
building the Sant'Andrea church in 1472. The architect had
just completed San Sebastiano (1460–70) under the marquis's

patronage. Alberti gained fame originally as a philosopher of architecture. Yet he also proved to be a brilliant architect and left a legacy of classically beautiful churches scattered throughout Italy. At the time, when they replaced the thick and dark of the medieval with light and air, they were considered almost sacrilegiously modern. For example, though Mantua's unfinished Basilica di Sant'Andrea takes many ideas from the Romans, including triumphal arches and the Pantheon-like vaulted ceilings, Alberti applies a High Renaissance lens to magnify their height and breadth.

The Pisanello and Mantegna frescoes in the Ducal Palace describe much of Luigi II's life. His pugnacious heritage from his father and *mano a mano* fights with his brother form an integral part of Pisanello's Arthurian Cycle, in which the artist uses his patron's battles as grist for his palette's mill. Without the Turk's life to give them a deeper meaning, the frescoes would only relate a courtly tale from the Celtic mists. The Ducal Palace's other world-class frescoes, by Mantegna, are absolute photographs-in-oil of the duke's private court and

require detailed explanations as to who's who in the Turk's domestic daily life.

When Luigi II died of the plague, his first son, Federico I, succeeded him, but for only six years. Federico's son, Francesco II (1466–1519), married the next great Gonzaga collector, Isabella d'Este (1474–1539).

Isabella d'Este's parents, the duke Ercole I of Ferrara and Eleanora of Aragon, betrothed her when she was just six years old to Giovanni Francesco Gonzaga. The courtier who carried Gonzaga's proposal reported that the child answered his questions "with a singular intelligence I could not have imagined." Isabella married in 1491 in what proved to be an unequal match. Although a noted soldier, Francesco II was intellectually uninspired, while his sixteen-year-old bride

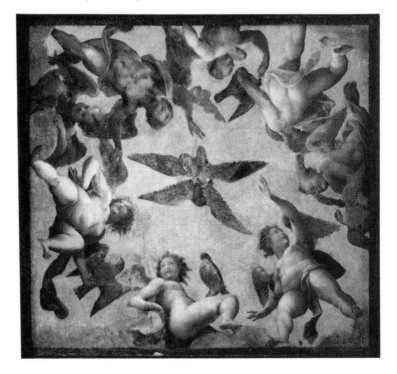

impressed the Mantuan courtiers with her fluent Greek and Latin and skillful rhetoric. She single-handedly transformed the Ducal Palace into a cultural center. From all over Italy her scholarship and brilliant wit attracted musicians, composers, and philosophers. She pawned her jewelry to buy etchings—Mantegna being one of the first great painters to experiment with scratching copper as an art form—as well as lutes, organs, agate vases, Greek busts, Roman vases, Egyptian scarabs, medieval French romances, and illuminated manuscripts. Unfortunately, few of the sixteen hundred pieces she crammed into her private *grotta* and *studiolo* remain in the Ducal Palace.

The marchesa wanted most of all to impress artists. Throughout her life, she pursued the works of Titian, Raphael, and Leonardo, just to mention the best known, and tried to attract the painters to her court. Having more taste than money, she could not lure them away from the much wealthier patrons in, respectively, Venice, Rome, and Milan.

Leonardo came but, like Titian, managed only to create Isabella's portrait. Titian's painting and Leonardo's red charcoal sketch have defined her image since: slightly bulging eyes, narrow lips, elaborately dressed in a costume that joins a halo of blond curls to overwhelm her small face. The most valuable painting she commissioned was Andrea Mantegna's *Parnassus* (1497), in which he represents her and Francesco as an obviously idealized Venus and Mars. The allegory now hangs in the Louvre.

If only they had been contemporaries, Johannes Vermeer (1632–75) would have been the perfect artist to capture Isabella's spirit and court. Truly a Renaissance woman, she played the lute and clavichord and sang with expertise. Her over twelve thousand letters are in themselves a singular

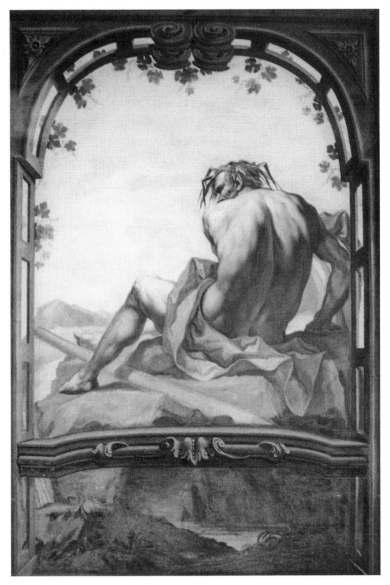

Scene in the Ducal Palace's River Room, where Italy's major rivers are honored in painting and in an altar festooned with seashells and coral.

history of the Renaissance in the Lombardy region.* She also made her own perfumes and soaps, which her sons would beg her to send wherever they traveled, on the request of their hostesses and paramours. She set fashion trends, including the bubble cap and gowns so décolleté they revealed half the

nipple—a plunge the French queen Anne quickly took. All readers should thank Isabella for her ingenious invention of page numbers for books, about fifty years after the invention of the Gutenberg printing press, and for publishing the very first editions of Virgil's and Petrarch's works. In short, she treasured all that Vermeer chose again and again as subjects to paint. When she died in 1539, she was obese, and her once remarkable costumes were now simply to be remarked on, but she had through her patronage maintained a reputation as the first queen of Europe.

Great artists continued to build, paint, and entertain the Gonzaga court, especially in the beginning of the seventeenth century, when Vincenzo I (reigned 1587–1612) opened his patronage beyond the "local artists" in the name of international humanism. Not only was Claudio

*Historians of fourteenth- to seventeenth-century Italy are absolutely dependent on the Gonzagas' well-preserved correspondences, which include not only their own letters but also those of others. As a result, Lombardy's concerns, battles, culture, and quotidian habits overly influence many studies on the Italian Renaissance.

Monteverdi (1567–1643) commissioned to write one of the earliest operas, *Orfeo*, but Peter Paul Rubens painted *The Gonzaga Family in Adoration of the Trinity* and the great poet Torquato Tasso frequented the court.

Though Vincenzo I began the Gonzagas' avalanche of debt, his three sons, who all became dukes—Francesco IV, Ferdinando, and Vincenzo II—continued it, ensuring the downfall of the Gonzaga reign. The final direct line of the Gonzagas fell on Vincenzo II. A semi-invalid, Vincenzo failed to annul his infertile marriage, despite his pleas to the pope that his wife was a sorceress who had bewitched him into marrying her and hints that she should be tortured Inquisition-style. To stem an economic crisis, he sold off a huge portion of the great Mantuan painting collection at pawnshop prices to the Stuart king Charles I, who lost it to Europe's museums and private collectors when imprisoned as a traitor.

After ruling for only a year (1626–27), the duke, on his deathbed, married his niece to a French prince, Charles Rethel Gonzaga Nevers. Four hours later he died, and with him died three hundred years of direct Gonzaga male rule. Despite the last Gonzaga duke's precautions in shoring up the city's power base, Mantua was doomed. Acting on orders from Emperor Ferdinand of the Holy Roman Empire, General Johann Aldringhen sent in thirty-six thousand foot soldiers an hour after midnight on July 17, 1630, who sacked the city and spread the plague then raging throughout Europe.

Although the French line of Gonzagas valiantly attempted to restore Mantua to her previous glory, her population was depleted by two-thirds, and her finances were equally reduced. The last of the Gonzaga rulers, Carlo II and Ferdinando Carlo, trashed the city as efficiently as any mercenaries. They earned the court a reputation for dissipation that lasted well into the

nineteenth century, when Verdi set his opera *Rigoletto* in
Mantua. Ferdinando tolled the death knell for the Gonzaga
legacy when he allied himself with France against Spain. Fearing
for his life, Ferdinando escaped to Venice in 1707 with hun-
dreds of paintings from the famous Gonzaga collection. When
he died a year later, they scattered to fill the palaces of other
dukes and princes, ending up in museums throughout Europe.

When the Austrians seized Mantua, Empress Maria
Theresa dotted the city with the eighteenth-century buildings
that still stand: San Barnaba, the Duomo's facade, Antonio
Bibiena's Teatro Scientifico, and the Palace of the Counts of
Arco. Napoleon captured the strongly fortified city in 1797,
and Mantua remained a French fiefdom until 1814. What
paintings the Austrians had not taken with them in their

retreat ended up on the Louvre's walls. Mantua joined in the *Risorgimento* in the 1860s, and Austria hanged the five Martyrs of Belfiore above Lago Maggiore for organizing against them. In 1866, the city joined the unified Kingdom of Italy.

With the Gonzaga family's demise, Mantua sank into obscurity. Venice, Rome, and Florence suffered their own sacks even before Napoleon, yet they retained enough great sculptures and paintings to remain the world's richest cities in art. Also, they reconsolidated their power and continued to influence Italian cultural life after the end of the Renaissance. Mantua, on the other hand, remained in the backwaters after the last Gonzaga died in ignominious exile in 1708, and only in the last century has it regained its wealth and prestige as an industrial center.

The Ducal Palace (Reggia dei Gonzaga)

Piazza Sordello, 39

Hours: 8:45 A.M.–6:30 P.M.; closed Monday.
Reservations recommended—call the number below, where they speak English.

Admission: L 12,000

Telephone: 0376 382150

Getting There: The Ducal Palace is on the northeast tip of Mantua, beside Lungolago dei Gonzaga, which faces Lago Inferiore (Lower Lake). From the train station, take Via Solferino to Via Fratelli Bandiera. Go past the Basilica Sant'Andrea heading straight north until you must veer right. Go straight into Piazza Sordello.

A warning: While I often manage to walk around the Ducal Palace by myself, usually one must join a tour. Binoculars recommended.

Pisanello

Even centuries after a piece of art disappears, art historians do not say it has been destroyed. Instead, it is perpetually lost. Like detectives hired to find missing children without even a faded school picture to help them search, art historians scour churches, castles, and palaces, often surreptitiously scrubbing at a corner to see if anything "lost" lies beneath the centuries' dust and grime. In the case of the lost Pisanello frescoes, the evidence was minuscule: Three letters describe a roof partially falling in on "the Pisanello room" in the Ducal Palace on December 14, 1480, and the steps the correspondents took to preserve the room. None of the letters mentions anything about frescoes. The artist had been dead for a quarter of a century, and this was the first and last hint, a single line referring to "the Pisanello room." Upon discovery of the letters, scholars assumed that, even if Pisanello had frescoed a room, multiple renovations yoked with destruction had eventually "disappeared" the room altogether.

Some historians made half-hearted searches of the castle. But in the mid-1960s, Giovanni Paccagnini grabbed the ends of these enticingly thin threads. He decided that the frescoes, if they existed (and no evidence had surfaced to say that Pisanello had ever painted them), must be in the old palace. He committed himself to looking for them for several years, if necessary. Soon he narrowed his search to the Sala dei Principi, named for the dozen or so medallions of Gonzaga rulers from the fourteenth century to the last prince, who lost the throne in 1708. Paccagnini found a sketch of a woman in a remnant of an arch. To the amateur eye, the feminine head could just as easily be a stain that someone had drawn a few

shapes around. But to Paccagnini, well known for his scholarship on Andrea Mantegna, the drawing obviously came from a hand of no little talent, trained at the end of the fourteenth century. He knew immediately he had discovered irrefutable evidence of Pisanello's frescoed room.

A false reed ceiling lowered the Gothic room from its loftier original. Between them lay a space that Paccagnini and his assistants could explore without ruining the artistically unimportant but historically interesting eighteenth-century frieze of

Gonzaga princes. The restorers crawled along the dark, damp, mildewed walls and scratched away layer after layer of plaster until they had enough evidence of a quattrocento battle scene to justify tearing apart the entire room.

Born in 1435 in Pisa as Antonio Pisano and called Vittorio, the great Renaissance artist always carried the nickname Pisanello, or "little pea," presumable because of his small stature. While he was a favorite in many courts—Naples, Venice, Mantua, and Rome, to name just a few—the only frescoes still extant are in Verona. Their stupendous and crowded compositions provide a sad intimation of the lost works. In Mantua, the frescoes are no longer lost, though some of the cycle must finally be admitted as being destroyed.

Two-thirds of the frescoes not only withstood the trials of time but also include an astonishing amount of detail. That any of the Pisanello frescoes survived at all is miraculous, given how centuries of plasterers and carpenters abused them. The tinkering with ceilings was the worst offense. For

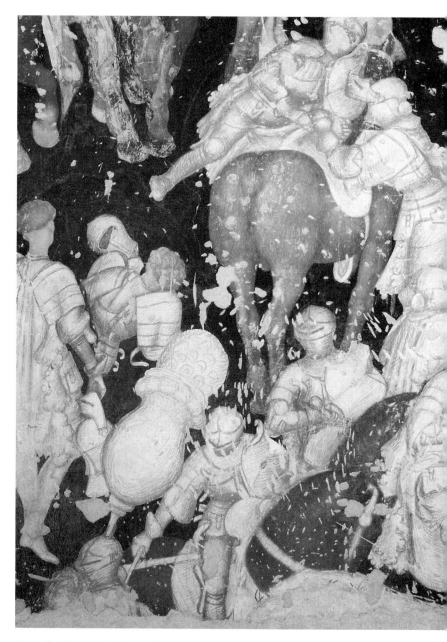

Pisanello, fresco: the end of the jousting in which Tristan conquered both competing kings' knights, littering the field with the dead and the wounded.

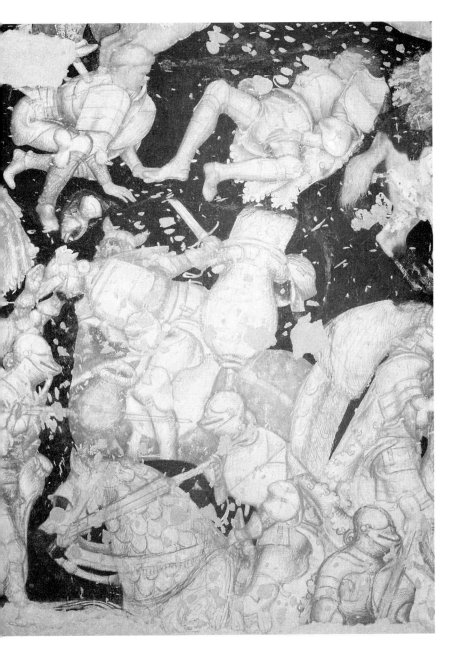

example, the Austrians who ruled Mantua in the nineteenth century added a ceiling and lopped off part of the two women who peer out from under a canopy. The Austrian-installed reed ceiling filled one of the women's images with holes. New ceiling supports placed close together dug more holes in the frescoes' upper regions. Erecting the scaffolding for workers to install the ceilings put holes in the lower regions.

The mildest offenders were the sixteenth- and seventeenth-century renovators who plastered over the old plaster. The Gonzagas ignored the room after the roof caved in, which allowed damp and dirt to soften the frescoes' surface. Also, the Pisanello plaster, or *intonaco*, was perfectly smooth and impermeable, which made it even more unsuitable as a surface for new plaster. Eventually the new plaster fell away, further destroying the frescoes. To make the new wall stick, builders *hammered the frescoes* to roughen their surface and create a better adherent. Yet they were not the most heinous culprits.

Pisanello, fresco: Tristan carries the banner to his love and the king's wife, Iseult (right), while her servant Brengwain (left) watches.

Two hundred years later, in refurbishing the room, the Austrians used the modern technique of completely destroying the old plaster until they reached the original wall, which explains why the lower half of the walls is blank.

All those ugly Gonzaga portraits replacing Pisanello's perfectly drawn court figures! Think of ripping down Michelangelo's *Last Judgment* and replacing it with medallions of popes.

Because of the exposed charcoal sketches, or *sinopie,* Paccagnini believes that Pisanello did not complete the cycle. If it had been completed, the room would have been named for the story illustrated, rather than the "Sala di Pisanello." Usually artwork is not referred to exclusively by the artist's name.

However they come to us, the Pisanello sketches demonstrate that, to the painter, drawing was the finest art of all. He evidently drew and redrew, often not because the original figure was inferior, but because he had another idea and wanted to execute it immediately. Little did he know that one day all his artistic energy and genius would be executed, literally, under men's big hammers.

The Meaning of the Frescoes

The Gonzagas collected French tales of chivalrous deeds the way modern readers consume mysteries or science fiction. Of the family's hundreds of volumes, sixty-seven were listed as French tales. Most of the Italian ruling families enjoyed the stories of chivalry, but the Gonzagas' collection so outnumbered the others and showed such depth and sophistication that even friends from outside of Mantua begged to borrow their books.

The tales were the romance novels of the era. Some of the stories are still well known, thanks to other artists who retold them. The Knights of the Round Table are alive in everything from Disney to Monty Python movies.

Given a choice between the two most famous heroes, Tristan and Lancelot, fifteenth-century Italians much preferred stories about Tristan, and the Gonzagas were no different.

The Gonzagas chose the Tristan tale not only to reflect their own glory but also to idealize their troubled time. A long-time ally of Venice, from which Mantua had gained many

riches and protection, Marchese Gianfrancesco became greedy. He wanted to take Vincenza and Verona and so allied himself against Venice with Filippo Maria Visconti. At first, in 1439, the battle looked promising and he occupied Verona. Soon afterward, however, Venice crushed the Mantuan army. The terms of the 1441 armistice were draconian. Gianfrancesco's heir, Ludovico, fought three brothers either overtly or covertly to retain his throne.

Paccagnini estimates that Pisanello worked on the cycle in 1447, when Ludovico II commissioned the cycle to represent his struggles and triumph. The story is of a tournament called the Battle of Louverzep between, on one side, King

Arthur and Lancelot and, on the other, King Amoroldo and the king of Scotland. As Iseult and her maidservant Brengwain watch, Tristan begins the battle on the side of King Amoroldo and slaughters or disables every one of King Arthur's knights, while wearing Iseult's colors of brilliant red and gold. At noon, he strips into his next layer, which are his own colors, sky blue and gold, and slays or dismounts everyone on King Amoroldo's side. He is declared the obvious winner and is told to take the standard, the flag in the middle of the battleground, as the grand prize to whomever he wishes. He carries it, of course, to Iseult, who sits beneath the canopy, pensively gazing at the carnage while her Brengwain looks on. (This is on the left wall, with the standard dominating near the front of the fresco's corner.) For more detail, see Paccagnini's excellent book on the battle,

Pisanello (Phaidon Press, 1973), in which he identifies many of the knights, or else search out the original source, *Tavola Ritonda*.

The Pisanello battle mirrors the marchese's fate with uncanny perfection. First Ludovico II had to conquer his enemies, then fight those who were his closest allies. He actually fought a vicious battle at Goito with one usurping brother, Carlo, which he describes in a letter to his wife with Arthurian poetry: a "beautiful battle" with many slain and many heroes. The marchese Ludovico resembled the Tristan who shed blood on all sides to bear the standard to the woman he loved but could never claim as belonging to him: Mantua.

Paccagnini believes that Pisanello left the cycle incomplete because the Gonzagas did not find it idealized enough. Theirs was a "beautiful battle," not one with dwarfs (though their palace contained a residence just for dwarfs) and knights sprawling and almost mooning the audience. Yet no further record comes to us of Pisanello's work after 1447, and he did not die until 1455. Previously he had been prolific, as the cycle testifies to just in itself. Could he have possibly taken sick, suffered a lingering illness, and died before completing even the lower figures? These would have probably been the main protagonists, who would have immediately revealed precisely which Arthurian tale the cycle represents. The story of the unfinished cycle is indeed lost for now.

Raphael's Tapestries

Given the chance, most art lovers prefer the Italian way of displaying paintings and sculptures: no reflections of glass and no boundaries except the cultural one that keeps us a safe distance away and prevents us from touching as naturally as we avoid fire. As even fixed prices at auction houses soar, the Italians seem insanely cavalier, leaving their works of art open and vulnerable to touch, to sharp objects, and sometimes to theft at an estimated rate of 30,000 pieces a year.

However, displaying art at all is risky. If we were rational, we would imitate some collectors and buy great paintings at auction for millions of dollars, then store them in temperature-controlled basements. But we are so far from rational that when a piece of art is suddenly encased, such as Michelangelo's *Pietà* in St. Peter's after a Hungarian madman chipped off the Madonna's nose, we resent the necessary protection.

To see Raphael's tapestries of the New Testament in an irrational setting is to see the copies at the Ducal Palace in Mantua. They hang in small rooms so close to visitors that you could touch them—but you won't, right?

The tapestries suffer for their accessibility. Humidity has stained those on the external wall. The large windows' natural light has faded the details and colors on a couple of them so that they are now, like photocopies, shadows of the originals at the Vatican. Some are not as accurate as the Vatican's, for the Flemish weavers fudged the details on those for which they did not have Raphael's original paintings, or cartoons, now hanging at the Victoria and Albert Museum. For the most part, though, the tapestries are exactly as good as the originals, in a few details better, and altogether offer a more intimate experience.

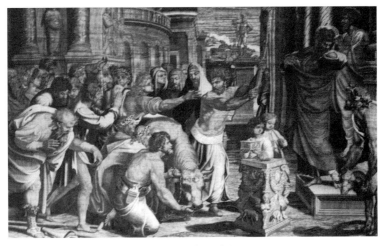

Raphael, *The Sacrifice at Lystra,* **woven from his cartoon.**

The Sistine Chapel in essence served as Leo X's throne and court. In order to make the chapel reflect his grandeur and historic role, the new Medici pope commissioned ten tapestries from Raphael, for which he paid him in full by December 20, 1516. Raphael designed the images of Peter and Paul, and one of Stephen, which begins Paul's story, to decorate the chapel's lower walls.

The Acts of the Apostles tapestries differ radically from those before them. The traditional tapestries were Gothic, like those that hang in the Metropolitan Museum's Cloisters. Based on Raphael's cartoons, the tapestries' figures instead move with elasticity, their faces writhe in recognizable portraits, and the architecture encloses Paul and Peter in familiar cityscapes.

Leo X and Raphael collaborated in selecting which scriptures to use and how to depict the Acts of the Apostles that they thought best illustrated the new pope's regime and philosophy. Pope Leo was expected to heal the schism caused by the revolt against his predecessor, Julius II. Letters and articles written during his ascension express the hope again and

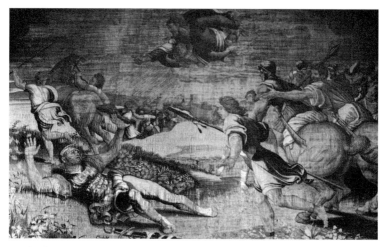

Raphael, *The Conversion of Saul,* woven from his cartoon.

again that he will live up to his name as a Medici (birth name Giovanni, son of Lorenzo the Magnificent). His supporters and observers hoped that he could cure his flock of the plagues of heresy and doubt. They referred to him as the Prince of Peace. (Popes often portrayed themselves as a Second Coming and rejuvenated titles that would have best remained dormant.)

Pope Leo would have had to be the Second Coming to make peace during the early sixteenth century. He died in 1521, just in time to miss the powerful Colonna family's first attack on Rome and the Vatican on September 20, 1526. The Colonna army stole the tapestries, which ended up in some private collections. The long arm of the Catholic Church, through a brutal edict from Clement VII (another Medici, birth name Giulio), quickly recuperated all ten Acts of the Apostles. Eight months later, in the 1527 Sack of Rome, looters again stole the tapestries. Again the Church's power to damn eternally whoever disobeyed them succeeded in restoring the ten panels to the Vatican.

This time, however, thieves returned some of the tapestries with burnt corners; fire would have separated the wool and silk from precious metals. The tapestries had been renowned for their gold and silver threads, which impressed those who could not appreciate the Raphael scenes purely for their artistic merits. The Mantuan tapestries are just plain cloth and, in fact, have aged better because of it.

Strangely, the Mantuan copies' history intertwines with the eight-day Sack of Rome. Isabella d'Este was desperate to get the Vatican tapestries. As wife of Francesco Gonzaga, Prince of Mantua, she was one of the foremost women of the Renaissance, and the major collector for the Ducal Palace. A guest of the pope, she was in Rome during the Sack and bought *Paul Preaching at Athens* and *The Conversion of Saul* from thieves. Her taste was always excellent and her morals loose when acquiring art. Pirates in turn stole the two tapestries from

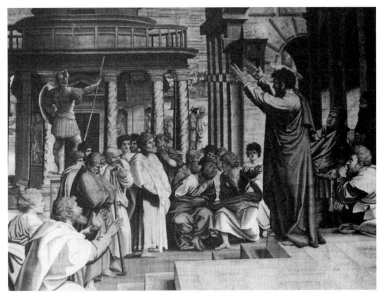

Raphael, *St. Paul Preaching at Athens,* woven from his cartoon.

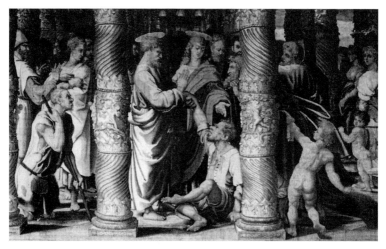

Raphael, *The Healing of the Lame Man,* **woven from his cartoon.**

her ship and carried them to Tunisia. Myth has it that Isabella escorted the tapestries home on her ship and single-handedly saved the Raphaels from sinking overboard during a storm while her crew fought the pirates.

Isabella never got her Raphael tapestries, but she passed along her desire for them to her son Ercole Gonzaga, who bought copies in 1559, minus *Paul in Prison.* The cardinal hung them in the choir of the court church's Palatine Chapel on feast days.

Austrian rulers moved the tapestries from Santa Barbara to the palace apartments in 1776, and they rebuilt the rooms in 1786 in order to accommodate the nine panels. They took the Raphaels home to Emperor Franz Joseph in Schönbrunn when Mantua returned to the Kingdom of Italy in 1866. The tapestries have hung in their present room only since 1919, when the Austrians returned them to the palace, then being restored into today's museum. All fantasies of "living with" the Raphaels, of being a Gonzaga and giving the fabrics a pat on the way to breakfast, are fantasies. They have never been

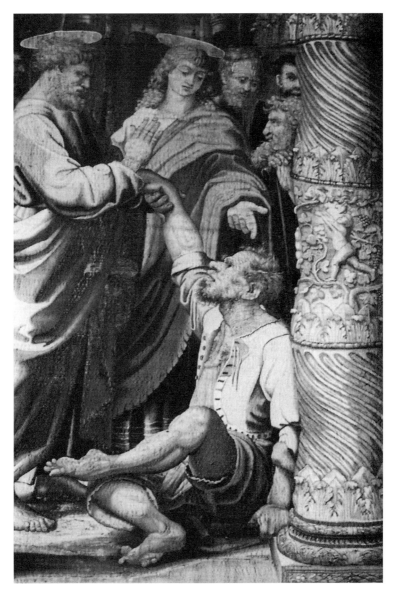

Raphael, *The Healing of the Lame Man* (detail), woven from his cartoon. The artist revolutionized the aesthetics of portrait and perspective in tapestries.

lived with and have always been museum pieces, on show only to attract and impress tourists.

The tapestries impress not only with their beauty but also with their strong messages of Catholicism, and of the pope as Peter's rightful descendant and unique interpreter of dogma. Their vehemence has irritated art historians ever since.

In the Stanza del Leone (the second Tapestry Room), *Christ's Charge to Peter* merges two biblical verses, one that delivers the keys of the kingdom to Peter and one that puts Peter in charge of the "flock." In the tapestry, the other Apostles are simply witnesses. Many biblical and art experts argue that in the New Testament all twelve men receive the responsibility for spreading the Gospel and tending the faithful, which was too Protestant an interpretation for Leo. He was, after all, the first pope to burn the upstart Martin Luther's books as being heretical.

On the other hand, Leo X bankrupted the Vatican within two years of becoming pope and forced the Church into unsavory deals in return for Indulgences, which fueled Luther's indignant fire and won him converts. At Leo's death, in 1521, the Church pawned the tapestries temporarily to replenish its coffers. He was as much a force behind Luther's successful Reformation as the Gutenberg press. If Leo's appetite for courtiers, artists, scholars, and jesters weakened the Church's fabric, a few illustrated biblical verses could not stem the unraveling.

The tapestries that pertain directly to the pope as doctor, such as *The Healing of the Lame Man* (first Stanza degli Arazzi, known as Stanza degli Imperatrici), are obviously references to Leo the Medici. A more subtle reference to Pope Leo lies in *Saint Paul Preaching at Athens* (second room, Stanza del Leone). To his contemporaries, the reference would have

Raphael, *The Conversion of the Proconsul (blinding of Elymas)* (detail), woven from his cartoon.

been blatant and the image obviously custom-made for the pope. Leo had established a Greek school in Rome to teach the classics; the Eternal City transfigured into the New Athens on the Tiber. Also, he had published one papal bull during his short term (1513–21), on the nature of the afterlife. This was precisely the subject Paul preached before the Greeks.

Pope Leo and Raphael worked together to determine the Acts' subject and treatment, and *Preaching at Athens* is the most both Leonine and Raphaelesque of the tapestries. In many of the tapestries—*The Healing of the Lame Man, The Conversion of the Proconsul* (or *Blinding of Elymas,* in the third room, called Stanza dell'Aquila), and *The Sacrifice at Lystra* (first room)—the architecture blocks the scene's composition to the point of claustrophobia, not a surprising device for an artist who is both painter and architect. In *Paul Preaching*, the architecture is evident but stays in the background so as not

to detract from the scene's drama. The stairs, viewed from their back, provide a subtle perspective.

Many figures in the tapestries are obviously made by Raphael's assistants, just as many are by the master hand. (Categorizing them into Raphael or his studio is a rewarding exercise and helps concentrate the mind on individual faces.) In *Paul Preaching*, Raphael obviously drew not only the figure of Paul, but also those of the couple in the forefront, Dionysius and Damaris. Raphael has rendered them so animated that they threaten to detract from the other, lesser figures. The two Athenians above them are also Raphael's. Their sleepiness and fatigue contrast with their neighbors' electrified response. Finally, Leo asked Raphael to put himself in Athens a millennium and a half ago, a respectable conceit in the Renaissance. He wears a red cardinal's hat and stands in pious attention on the right. Next to him stands the director of the Greek school, Janus Lascaris, a famous scholar and a friend of the pope's.

Almost inevitably, given the artist's and the patron's concentrated energy, the *Paul Preaching* tapestry is considered one of Raphael's two masterpieces in the series. It was, after all, one that Isabella d'Este chose. The other work considered great even in this exalted company is *The Miraculous Draught of Fishes* (third room). Leo must have shown Raphael a medieval Greek illustrated Bible in the Vatican library, in which the boats are also mere slivers rather than the usual rounded, more modern dinghies. Again, the patron's interest in the image contributed to its beauty, especially since Leo certainly prayed for a miracle that would drown his ship in an overabundance of ducats.

La Camera degli Sposi

The Ducal Palace's Camera degli Sposi, painted after Pisanello's Arthurian Cycle and before Michelangelo's Sistine Ceiling, is simply called *the* Painted Room. La Camera Dipinta, as Ducal Palace papers refer to it, brought Ludovico II the fame and power that he sought in convincing Mantegna to move from Padua to Mantua.

After Pisanello died in 1455, the Marchese of Mantua asked Mantegna to accept the position of court painter. At the time, Italian society revered architects and considered painting to be a craft rather than an art. As Benvenuto Cellini wrote, "The art of sculpture is eight times as great as any other art based on drawing, because a statue has eight views and they must all be equally good . . ." For example, Leonardo's reputation as a great artist did not solidify in Italy until the early 1500s, when he displayed a clay model of a gigantic funeral monument in Milan.

Mantegna sensed a changing wind, however, and helped it shift. In order to leave Padua, he asked the marquis for enough money to live as royalty and to build a palace in Mantua. In return, Mantegna created seminal works of art that generations of painters imitated. The duke's son honored the artist for contributing to Mantua's greatness by burying him in the city's most prestigious, though never completed, church, the Sant'Andrea.

The twenty-four-year-old native of Isola di Cartura frescoed the Ducal Palace with such originality and magnificence that one could say he started the tourist rush on Mantua. Long before Mantegna completed the frescoes, aristocrat and scholar alike flocked to the Ducal Palace to see

what was commonly referred to as "the most beautiful room in the world." Each new visitor left the palace speaking of Ludovico II as a man of powerful influence, broad vision, excellent taste, and astonishing boldness.

La Camera degli Sposi, as it is now called, translates as the Marriage Room. An equivalent is what we call the master bedroom, which also accurately defines the chamber's functions. It did at times serve as a bedroom. Ludovico once wrote to his wife, Barbara of Brandenburg, that on his return they should spend time together in the Camera picta, and time apart in their other rooms. A canopied bed once stretched beneath the ceiling's oculus, or eye. The frescoes suffered from curtain hooks gauging holes in them. Though a bedroom, the room also enshrined Ludovico as complete master. He conducted state business in it and often entertained important visitors beside the bed.

Instead of decorating the room with the usual conspicuous wealth of tapestries and marble, the Gonzaga marquis chose to illustrate the room's various functions. The paintings mirror him as both public and private man. (Admittedly, the mirror is a hopeless flatterer, since he and his family were renowned for their ugliness.) Like the yin-yang symbol, the private leaks into the public, and the public interferes with the private.

Above the fireplace on the north wall sits the private man, "Luigi." He lounges comfortably dressed among his family, obviously at home. However, the public interrupts the private scene, as Ludovico has received a letter from Bianca Maria Visconti saying that her husband, Francesco Sforza, has fallen ill. Ludovico tells his secretary what to answer: he will come to the duke's assistance as captain of Milan's troops, to discourage usurpers.

Mantegna, La Camera degli Sposi (detail). Ludovico II's (seated left) court and family.

From left to right in the detail of "The Court," the group includes Marsillio Andreasi, the marquis's secretary, who leans over the marquis. Next is Ludovico, who has placed

closest to himself those who obey him without question: his dog and his most trusted servant. The marquis's second son, Gianfrancesco, stands at stiff attention behind his father. Notice the artist's cleverness in showing only Gianfrancesco's single finger on the shoulder of his younger brother Ludovico, protonotary and future bishop of Mantua, from which the viewer can tell that Gianfrancesco holds the boy with both hands. The daughter Paola kneels with an apple in her hand to eat, her back obviously curving in the Gonzaga hump. She gazes at her mother, Barbara of Brandenburg, whose blue-gloved hand unconsciously clutches the golden fabric in her lap as her husband orders that his entourage ready themselves for the trip to Milan.

Between them, in the back, a figure stands dressed in black. Vittorino da Feltre cannot have actually stood with the group, for he had died almost two decades before. The portrait, however, unquestionably symbolizes Ludovico's beloved tutor. In fact, to be accurate, the fresco should portray Ludovico also standing, as he did whenever in the teacher's presence. Vittorino can without exaggeration be called one of the fathers of modern education, both in his philosophy and in its practice. Naming his school La Casa Giocosa, Vittorino worked at creating a truly "joyful house" that pounded Greek, Latin, jousting, and good humor into an entire generation of Gonzagas.

Next to Vittorino and behind the marquise stands her third-born son, Rodolfo, while the "court dwarf" stands beside her—the vast Ducal Palace included quarters specifically for dwarfs. Above the dwarf, the first Gonzaga daughter, Barbara, shows her youthful beauty in three-quarter face. The men in black are tutors; the other men in the Gonzaga colors, wearing gold tunics hemmed in white with gray and red hose,

are unidentified but of the clan. Others are dignitaries (the man in red hose holding his gloves) or couriers (the man reaching into his tunic for a letter).

The depiction of the dog Rubino that lies beneath Luigi's chair is an intimate portrait. Even beneath the years' abuse to the fresco, Rubino's eyes contain liquid highlights and yellow soul, his nose frosted with the first sign of age, his chest a masculine expanse of feathers.

Ludovico had the largest family of any of the Mantuan Gonzaga rulers, and several of his children are missing from "The Court." Dortea and Susanna died immediately before Mantegna began painting; their deaths evidently provided impetus to begin the family portrait. Cecilia is not in the group, for no apparent reason, nor is Federico or Francesco, the marquis's first- and second-born sons, who are portrayed on the west wall.

In large and small details, the west wall represents the Marchese of Mantua rather than Luigi. On his way to Milan, the marchese stopped in Bozzolo on January 1, 1462, to see his sons Federico (right side, gold tunic flung over the shoulder to reveal green lining) and Francesco (center), who were serendipitously returning from Milan at the same time that their father was rushing to rescue the city. They had traveled from Rome to visit the now ill Sforza duke to thank him for his help in making Francesco a cardinal, the first in the Gonzaga family. Francesco is holding the hand of his youngest brother, Ludovico, who is holding the hand of Federico's son, Sigismondo; the third child, Gianfrancesco, is also Federico's son. Though Sigismondo was not yet born in 1462, and Ludovico was in reality only a year old, they grew up to attain high posts in the church and thus belong in the portrait that foretold the nine cardinals of the Gonzaga line.

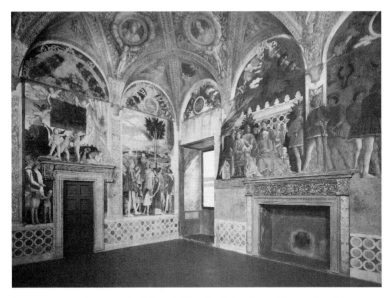

Mantegna, La Camera degli Sposi (detail). "The Court" is on the right, "The Meeting" on the left.

(Gianfrancesco was also not yet born and did not enter the church, but sibling rivalry in the Gonzaga family was a bloody affair. He could not be left out of the group portrait simply to clarify the symbolism.)

Behind the rendezvous lies a great landscape replete with Gonzaga symbols. Though an inaccurate sketch of Rome, which Mantegna had seen only in prints, the landscape is a backdrop of figures conducting Gonzaga business. Between the heads of the marquis and the cardinal, lines of men excavate from the bowels of the hillside. In fact, Ludovico was excavating around Mantua at the time, searching for Roman and Etruscan artifacts. Above the archaeological site, a Roman ruin is in good preserve. On the fresco's far right, above the transport line, two men work on building blocks with which they will continue to restore the ruin. The symbols all tie the Gonzaga family to Rome's history and greatness. Finally,

above the two men and in front of the city walls, a man hangs on a gibbet, a symbol of il Turco's ruthlessness as governor, a characteristic that lay contentedly next to his humanistic education and his interest in ancient and contemporary art.

"The Meeting" is a much more formal portrait. In contrast to Rubino, the figures of the Great Danes and hounds that the servants hold contain no painted highlights and stare out with stupid, cartoonlike faces. They merely symbolize Ludovico's role as hunter and therefore captain for the Lombardian ruling class and do not claim his affection. Yet the private seeps into the formal. Despite his urgent official business in Milan and his military dress, Ludovico greets his sons with obvious affection. The two servants who wait with Ludovico's horses are beloved enough to deserve animated portraits. The man on the left is portrayed as a verbal pugilist and makes his point heatedly to the tall, thin, shy listener on the right whose well-coiled ropes reveal his conscientiousness. Missing from the scene is the eighty-strong entourage with which the seventeen-year-old cardinal traveled—Mantegna purposefully painted him to look more like a thirty-five-year-old, to make the appointment appear more earned than political.

Outside the two walls' frescoes, the public and private are separated with a velvet-covered iron fist. For the private, the room's most intimate, as well as imitated, detail is the oculus. It is the first of its kind, which is like saying Mantegna was the first to think of painting a portrait or a landscape. Oculi immediately decorated church ceilings all over Italy, and imagining a time before they existed is difficult. Not only did Mantegna invent the ceiling "eye" that opens a room and seems to fill it with light, but it was also the first thing he painted when he started his frescoes on what a graffiti date

(in the splay of the northwest window) says is June 16, 1462. This idea alone could have earned him the private palace he negotiated with the marquis.

The oculus fills an otherwise claustrophobic space with light and air and is the room's most personal image, though none of the faces peering down has been identified. The eye spreads not only light but also laughter. The putti are levity with wings: one cries as his head is stuck in the balustrade, another is likewise stuck and his friend makes devil's horns with his hair while holding a threatening apple above the sleepers. Even the angelic putto who leans next to the peacock means mischief as he brandishes a peashooter. Most of the male babes are painted at angles that today in the United States would result in Mantegna's arrest for child pornography. Luckily, in quattrocento Italy the perspective was just very humorous.

Imagine the Gonzagas waking up to see the portraits of plainly attired servants smiling down at them, one woman with her hair not even dressed, almost threatening the equally tousled head below her with a comb. A fashionable woman with an elegant coif dangerously rolls the rod that supports the citrus planter, while an African servant smiles and encourages her to dump the tub onto the bed below. The oculus contains the kind of group portrait that Renaissance princes like Ludovico were finding in Etruscan tombs, in which master and servant resemble each other in dress and looks and show an obvious affection for each other that speaks volumes about the society in general.

While the ceiling's oculus supplies an illusion of light, its ribbed vaults festooned with ribbons give the illusion of space. They also frame the purely public icons in the room, portraits of eight caesars. Their names are etched beside all

except Nero, perhaps out of the superstition that writing his name would raise his evil spirit. The medallions in the center of the niches are also entirely public in that they symbolize the Gonzagas' power, mythos, and dedication to good government.

The frescoes have badly disintegrated. Their popularity through the centuries left a trail of letters that document the Gonzagas' efforts to keep the paintings safe from the ravages of dripping water and excessive humidity. A nick in the dwarf's chin and in one of the ceiling cupid's testicles give evidence to Imperial soldiers using the paintings as target practice when they sacked Mantua in August 1630. One can only hope that the hard frescoes ricocheted the bullets back toward the mercenaries' own privates.

As with Pisanello's frescoes, the details lacking in the Marriage Room's figures have flaked off, the result of Mantegna's failed experiments. Married to the sister of the Bellini brothers, who dominated Venetian painting, Mantegna tried, like them, to experiment with oil. On the Camera degli Sposi, he paints details on top of the hard, nonabsorbent frescoed surfaces. Thanks to the artists who sketched copies of the Marriage Room scenes, we know in general what fell off. As late as 1787, engravings show large embroidered decorations that originally covered Barbara of Brandenburg's dress. Her son's pleated doublets quivered with a tight-feathered pattern that is like a Versace dress. (Rather, Versace borrowed ideas from costumes like theirs.) The curtains alone must have demanded a significant portion of the years Mantegna took to complete the room, yet today all their intricate curlicues and gold leaf are gone. As if time shows pity toward the young and beautiful, Barbara wears the best-preserved dress, which hints at the original fabric's lushness.

Mantegna, La Camera degli Sposi (central panel). Putti hold the tablet with which Mantegna signs, dates (1474), and dedicates the room to Marchese Ludovico and his wife, Barbara.

Nevertheless, Mantegna's frescoes still leave plenty of detail to linger over. When Ludovico sits in "The Court," his every toe shows through his soft slippers. When he stands in "The Meeting," his teeth glimmer unevenly and his eyes wrinkle as he begins to smile at his son. The wings on the putti who hold the tablet announcing Mantegna's achievement of 1474 sport such detailed wings that their markings, though stylized, identify their species of butterflies: swallowtail (lower right), cabbage white (upper right), red admiral (middle of bottom trio), and wall brown (upper left).

Centuries of fires and candles do not seem to have darkened the frescoes the way that they did Michelangelo's Sistine Ceiling, and the palette in the Marriage Room is close to what Mantegna painted. The Ducal Palace's every generation showed solicitude in preserving his work and must have kept

the fires low, the candles few. What a palette they saved! In just one detail in "The Meeting," above the servants, a tower of cerise pink glows against a periwinkle sky, while grass green softly stains the castle's putty walls. The extravagant rock formations, rendered more from imagination than from the typically flat Mantuan landscape, combine burnt orange, olive, and rose, as well as the expected browns.

Here again Mantegna demonstrates his sense of humor, as the curtain's corner has come untied and reveals the landscape that otherwise would have been hidden. The lone finger's owner has been gone so long (since the Sack?) that no engraving exists to show us who is pointing. Curtains also fold back in "The Court" to reveal the family scene and the butterfly putti's tablet.

In his humor, which intertwines the entire room like a ribbon, Mantegna personalizes and lightens the most formal and public scenes. He even inserts a self-portrait that stares out midway in the decoration between his tablet signature and "The Meeting," literally with warts and all. Perhaps he thought that to portray his own misshapen face in a more truthful light than he had his patrons' might make visitors, or the gods, less envious of him as *the* painter of *the* Painted Room.

Florence

In most Italian cities, princes, kings, cardinals, and popes had to bribe great artists to move into their palaces as full-time sculptors, architects, and painters. From the Renaissance's very conception, however, Florence simply bore and bred artists at home.

Florentine native Dante acted as a father to the Renaissance in part by writing in the vulgate rather than in Latin. He identified the Florentine dialect forever as literate Italian, which bestowed a certain cockiness in his friends and *paesani,* Florence-born Cimabue and Giotto, concerning their own art. Cimabue walked by Giotto while the boy was drawing a sheep on a rock and immediately accepted him as an apprentice. The biography of Cimabue opens Vasari's *Lives of the Painters, Sculptors and Architects,* in which Vasari writes of Giotto: "Assisted by nature and taught by Cimabue, the child not only equaled the manner of his master, but became so good an imitator of nature that he banished completely that rude Greek manner and revived the modern and good art of painting, introducing the portraying well from nature of living people, which had not been used for more than two hundred years."

Once Giotto had released the human figure from cen-
turies of Byzantine rigor mortis, Florence and her environs
gave literal physical birth to the artists who invented new
rules, only to break them, too: Filippo Brunelleschi, Fra
Angelico, Filippo Lippi, Benozzo Gozzoli, Alessandro
Botticelli, Domenico Ghirlandaio, Leonardo da Vinci,
Benvenuto Cellini . . . on and on the list unfurls. The city lav-
ished enough freedom and money on her *enfants terribles*
with which to design buildings, paint portraits, and sculpt
grand figures that they often never needed to leave home,
despite the "foreign" princes' bribes.

As a result, the tourist lines to the Uffizi, the Academy,
and the Pitti Palace also unfurl for blocks. Florence's very
fecundity as a mother of art condemns her visitors, as with all
condemned souls, to suffer eternal tortures in an uncomfort-
ably hot and crowded place.

To see the Uffizi's portraits by native son Bronzino requires
making reservations months in advance. To gape up at the
seventeen-foot-tall* perfect man that another Florentine,
Michelangelo, sculpted from a "spoiled" slab of marble requires
standing in line for hours in front of the Galleria
dell'Accademia. Altogether, to spend most of one's short time
in Florence waiting to catch a glimpse of the original of one's
refrigerator magnet requires a deep passion for Renaissance art.

Offbeat museums can entertain almost as well and require
much less patience. The Opificio delle Pietre Dure, for example,

*The *Davide* is indeed seventeen feet tall, not fourteen as recorded for almost
five hundred years. In early 2001, the Stanford Digital Michelangelo Project
announced the new height, which it determined by re-creating the statue
from scanned images over a three-year period, coincidentally the same
amount of time Michelangelo took to sculpt the original. A tape measure
might have revealed the same discrepancy in a minute and for tens of thou-
sands of dollars less.

displays entire landscapes designed from the shavings of semi-precious stones. Two museums, the Stibbert and the Zoological Museum della Specola (Museo della Storia Naturale e la Specola), and a pilgrimage to honor the Brownings can fill a morning with alternative, non-Mannerist oeuvres. Elizabeth Barrett Browning's tomb lies down the street from the Stibbert at Piazza Donatello in the English Cemetery (Cimitero degli Inglesi). La Specola can be found on Piazza San Felice, as can the poets' flat (no. 8, first floor) in the Casa Guidi.

Afternoons also pass more pleasantly in Florence when one hides in its extensive gardens, the city's most underreported diversion. The Boboli Gardens behind the Pitti Palace offer long manicured paths for either meandering exploration or an invigorating walk up the hill to the Porcelain Museum.

Even farther afield and across the Arno lies the long, winding Viale Michelangelo to Piazzale Michelangelo. While full of tour buses and their cargo, the piazzale nonetheless exhibits a panorama of Florence that stretches into one of the most beautiful 180-degree views in Italy. If you feel moved to

see something other than a postcard picture, walk around the piazza's periphery and examine the medieval town walls. Notice laundry hanging where the poor live. At night, the huge square tempts an after-dinner crowd escaping the city for cleaner and cooler air.

Or avoid the tourist- and Florentine-crowded summit and climb only partway up the Viale Michelangelo. Keep a sharp lookout for a rose garden, and benches under deeply shading trees, and even a fountain sparkling in the gloom. At any point that looks appealing, stop walking or get off the bus. (Of course, if you are not interested in walking back down, note the bus stops to return to town. The fountain, roses, and shade are at bus stop Michelangelo 2.) Smell the proverbial roses, unpack a lunch, and take pleasure in life. If imitation is truly the most sincere form of flattery, then the most sincerely flattering way to tour Florence is to adapt the citizens' manner of leaving a few hours in the day for good food, fragrant flowers, and a well-deserved rest from all that beautiful art.

Opificio delle Pietre Dure

Via degli Alfani, 78

Hours: Daily 9 A.M.–2 P.M.; closed Sunday and holidays.

Admission: L 4,000. Ticket sales end half an hour before closing. Free entrance for academic groups who present a letter from their school.

Telephone: 55 294115

Fax: 55 287123

For ticket reservations, call 055 294883 Monday through Friday 8 A.M.–6:30 P.M., Saturday 8:30 A.M.– 12:30 P.M. Tickets cost more with reservations.

E-mail: opd@dada.it

Getting There: The museum lies between the Duomo and the Accademia di Belle Arti. From the Duomo, take the Via Ricasoli, then take the second right (Via degli Alfani). The museum is on the left. From the Accademia, take Via Ricasoli south and make the first left.

Stibbert Museum (Museo di Stibbert)
See description.

Museo della Storia Naturale e la Specola
See description.

Cimitero degli Inglesi (English Cemetery)
Piazza Donatello, 38
Hours: Daily 9 A.M.–1 P.M., 3–5 P.M., except holidays; ring at the main gate. Elizabeth Barrett Browning's tomb is left of the central path.
Telephone: 055 582608.
Admission: Free (ring at the gate).

Getting There: From the train station, take Bus 33 south to Piazza Donatello. Buses 8, 70, and 80 also drop you off right at the cemetery.

Casa Guidi (Brownings' Flat)
Piazza San Felice, 8, first floor
Telephone: 055 354457
Hours: April through November on Monday, Wednesday, and Friday, 3–6 P.M.
Admission: Donation requested.
For renting the Brownings' apartment for short periods, contact: The Landmark Trust Shottesbrooke, Maidenhead, Berkshire SL6 3SW, England

Tel: 44 1628 825925

Fax: 44 1628 825417

E-mail: bookings@landmarktrust.co.uk

In the United States, call 802-254-6868. You must buy
its handbook, the cost of which is refunded from the
booking.

Getting There: Same as for La Specola. The Piazza San
Felice lies almost next door to the Pitti Palace, in
Palazzo Torrigiani. To get to the Pitti Palace from the
Duomo side, cross the Arno River at Ponte Vecchio and
walk straight down Via Giuccardini. To take a bus to
the Pitti Palace from the train station, catch the D and
get off at the Pitti Palace stop. Once in front of the Pitti
Palace, walk away from the Arno on Via Romana and
look for Piazza San Felice, 8.

The Boboli Gardens

Palazzo Pitti

Telephone: 055 218741

Hours: 9 A.M. until dusk, closed first and last Mondays
of the month.

Admission: L 5,000

Getting There: The Boboli Gardens are behind the Pitti
Palace. From the Duomo, cross the Arno River at Ponte
Vecchio and walk straight down Via Giuccardini.

To take a bus to the Pitti Palace from the train sta-
tion, catch the D and get off at the Pitti Palace stop.

The Porcelain Museum

Casino del Cavaliere, Giardino di Boboli (Palazzo Pitti)

Hours: 9 A.M.–1:30 P.M.; closed the first and last Mondays of the month.

Admission: Tickets are L 5,000; the same ticket will get you into both the Boboli Gardens and the Pitti Palace's Silver Museum (same hours, telephone 055 2388710 or 055 2388709; the Silver Museum is closed the first, third, and fifth Sundays of the month).

Telephone: 055 2388605

Getting There: The Porcelain Museum is straight up the Boboli Gardens' main pathway.

Piazzale Michelangelo

Getting There: Walking from the centro, go across the Arno to Piazza Poggi and walk up Viale Pioggi, which might take an hour. You could also take the number 13 bus from the train station; it will drop you at Piazza Poggi or take you up Viale Michelangelo to the piazzale. Or take the number 12 bus, also from the train station, or the 39 from Piazza Ferrucci, which is a bit out of town up the Arno. You can buy tickets at tobacco shops or newspaper stands.

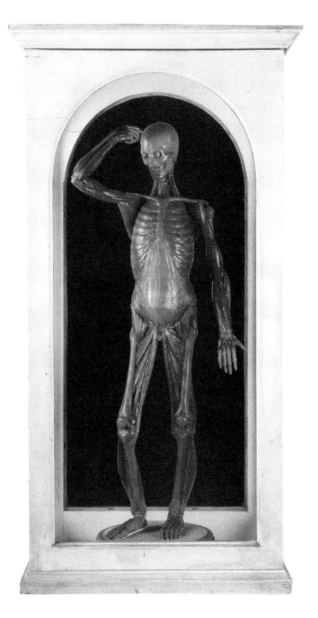

Wax model depicting a male's bone structure at La Specola.

La Specola

The anatomical wax models in the Museo della Storia Naturale e la Specola, or just La Specola, reveal what we look like when stripped of skin, dimples, freckles, jowls, sloping noses, furrowing brows, hair, and fat. Underneath the decoration, we are sinewy, bony, well shaped, and vulnerable. The models' exposed organs and skeletons nestle too close to us, making us see ourselves as we would rather not, trembling in the details between beauty and beastliness.

La Specola refers to the astronomer's tower added onto the museum soon after it opened to honor Galileo. The Observatory also encapsulates the experience of looking at full-sized anatomical models, for they look back at us. The sculptors did not work from imagination but from corpses.

Were the wax sculptors in La Specola's workshops justified in scavenging corpses for bones with which to cast molds critical to making anatomically correct human models? Absolutely. The *modellatori* who sculpted the first wax models in the eighteenth century for Florence's Museo della Storia Naturale contributed tremendously to medical knowledge. Surgeons and doctors continue to visit La Specola today to study the sculptures and learn the exact road map of veins, the topography of muscles, the mechanics of joints and eyes.

Eventually the statues' beauty and craft inspire awe and overwhelm any dismay visitors harbor over the multitude of human skulls, joints, and femurs that served the sculptors. They made the human effigies long ago, mostly between 1771 and 1830, and created many from chalk drawings of corpses or quick wax studies rather than from plaster molds set from the bones themselves, section by section. Outrage

seems antiquated and echoes the Catholic Church's virulent opposition to learning anatomical lessons from the human corpse. The modern opinion of allowing humans to serve science prevailed as early as the eighteenth century, when businessmen paid to sit among medical students and witness dissections.

After all, even the Church has regularly and casually used real skulls and bones as memento mori. Compared with other Italian sites, La Specola uses a modicum of human flesh for its displays.

During the time of pilgrimages to Jerusalem, wealthy patrons often funded their churches' missions to the Holy Land. The pilgrims returned with enough earth from Jerusalem to bury sometimes a couple of dozen patrons at once. Then the next generation of *figli di papà,* or spoiled brats, wanted the same sacred benefits of a burial in what was literally holy land. What to do with the original underwriters? Exhume them and, in churches around Italy and Spain, pile their bones on the sides to the ceiling.

In Rome, an anonymous Capuchin monk, frustrated as an interior decorator, took the bones of his distinguished brothers in the Santa Maria della Concezione Immacolata's funerary chapel and created a new ambience. He made Sacred Hearts out of small lower ribs, a crown of finger-bone tercels and vertebrae, and a skull that tops the heart in a frame of fanning pelvic bones. This is just one of many, many of the Capuchin chapel's bizarre ornaments. In comparison, Florence's La Specola is absolutely Protestant.

When we consider the number of corpses needed to create each model, however, the scales weigh in favor of awarding La Specola the title Most Macabre Italian Museum. The true fathers of the wax models are Felice Fontana, who opened the ceraplastic workshops in 1771, and those he hired: the modeler Giuseppe Ferrini, the anatomist Antonio Matteucci, and Clemente Susini, who became the most renowned modeler of Florence. They required an average of two hundred fresh corpses to create each of the 513 human figures and 65 of comparative anatomy.

The Dark Ages had swept methods of preservation, familiar to the Egyptians, out of the library of human knowledge. The Italian wax wizards fought against time and heat's rot as they created and revised the scientifically perfect depictions of flayed humans. Their most inaccurate models are of the brain, which disintegrates more quickly after death than the other organs and sags into a milky mush. The *modellatori* worked feverishly to fill orders from Italy's medical schools for the wax models, which would end the universities' need to exhume corpses for anatomical studies.

The Mantuans have said since before the Romans, to make an omelette, you have to break some eggs. At La Specola, the eggs were already broken when the corpses arrived at the Palazzo Torrigiani on wooden carts from Santa Maria Nuova, over a mile away, and the omelettes they made have continually fed the intellect for three hundred years.

Along with medical doctors and researchers, teenagers regularly throng the museum. Even though they are at the age when the gothic is most fascinating, the boys and girls probably find the models too pungent a lesson in gross anatomy, a term to which La Specola gives new depth.

The museum's sex education is especially nitty-gritty and could ruin many budding romances. The most famous of La Specola's models, *The Anatomical Venus*, comes apart layer by layer to reveal first the rib cage and mammary glands, then the intestines and heart, then the major organs, until finally her uterus opens to reveal a four-month pregnancy. A male model reveals the exact web of nerves that lie on the penis. In another model focused on reproduction, a fetus lies *in utero*, its tiny feet facing us, its back muscles straining to push out of the gaping vagina exposed at such an angle as to show clearly how unequal the small opening feels to the chore

ahead. The museum displays models of fetuses from one to nine months of age. Even the least squeamish do not linger over the museum's models of half-dissected babies. Like the adult models, the infants refuse to look dead, their eyes shut merely in sleep, their lips smiling in dreams, their hands curled trustingly, palms up.

The museum might never have existed if the Grand Duke of Tuscany, Peter Leopold of Hapsburg-Lotharingen, had not sold valuable pieces of the Medici's collection to finance it. In order to build a single gallery for Florence's scientific artifacts, which in 1771 were scattered throughout the city, the Grand Duke had to break an egg himself, in the form of the mid-eighteenth-century will of a Medici protector. Ignoring the directive that the Medici collection stay in Florence, he sold many of the most valuable pieces and with the proceeds bought the Palazzo Torrigiani. In 1780, he commissioned the addition of an observatory tower, which gave the museum its contemporary name. Making scientific artifacts available to the general public was one of the museum's primary missions. One can only imagine the layperson's relief when the museum's name changed from the Imperial Regio Museo di Fisica e Storia Naturale (the Imperial-Royal Museum of

Wax study of facial and neck muscles.

Physics and Natural History) to Museo della Specola, or the Observatory Museum.

Taken mostly from the Uffizi, the original collection included some natural history samples of minerals and seashells. As a result, La Specola is the world's oldest zoological museum. The collection of anatomical figures started with four by the most famous of La Specola's sculptors, the Sicilian Gaetano Giulo Zumbo (1656–1701).

In 1824, La Specola found a new supporter in the young Leopold II (1797–1870), whose blond locks earned him the Florentine nickname "Canapone" (*capelli canapini* means "white hair"). Leopold reinstated scientific lectures and upgraded the museum from a tourist site to a university extension, in which the hoi polloi were allowed entrance from 8 to 10 A.M., and the hoity-toities after 1 P.M. (notice that many museums still close in the early afternoon to the average tourist). The museum expanded under the Grand Duke's leadership to feature a room dedicated exclusively to Galileo, including instruments invented by the astronomer: his first telescopes, the jovilabe (a device for predicting the positions of the moons of Jupiter), and lenses, one of which famously exploded a diamond. La Specola declined from its mid-nineteenth-century zenith as Florence built other universities and scientific museums that had, by caveat, a more legitimate claim to La Specola's books and objects. For example, the Museum of Science History (Museo di Storia della Scienza) now displays Galileo's instruments, even though La Specola was built specifically to honor the astronomer and displays a sculpted tribute to him on the first floor. By 1924, universities and libraries had denuded La Specola of everything except the zoological collection (rooms II through XXIV) and the anatomical models (rooms XXV through XXXIV).

Behind the dissected humans and the largest collection of shells, insects, and vertebrates and invertebrates in Italy, in room XXXIII behind the exit room, La Specola quietly displays a few other spectacular yet unknown pieces by the father of the wax anatomical model, Gaetano Giulio Zumbo.

Born to an aristocratic Sicilian family, possibly the son of a slave girl named Zummo, Zumbo came in 1691 to Naples, where he made the first vignette of three scenes of the plague, titled *The Theater of the Plague. The Triumph of Time* and *The*

Susini, *The Anatomical Venus.*

Corruption of the Body (with the woman seated in the middle with her head in her arms) he created when in Florence between February 1691 and April 1694. (In *The Triumph of Time*, now known simply as *The Burial*, a later artist added a medallion of what has always been accepted as a portrait of Zumbo.) Cosimo III commissioned another *teatrino*, now in private hands, and bought *The Plague* outright, which made Nathaniel Hawthorne shake his head a century and a half later and claim, "They do him no credit, indicating something dark and morbid in his character."

Also displayed in the Zumbo room are the fragments of Zumbo's *Syphilis* that survived the 1966 flood. Finally, La Specola contains one of the seminal works for all realistic waxen images, from its own pieces of art to Madame Toussaud's tourist baits, and that is what is called simply *The Anatomical Head*. It can also claim title to Most Macabre Piece in the Most Macabre of Museums, for Zumbo created it before he had perfected the techniques for anatomical modeling that he invented. In this first experiment, he simply poured wax over a human skull and molded the details around the empty sockets.

The Florentines welcomed Zumbo, for they believed wax to be a legitimate art medium, not inferior to marble and wood. Rich and poor made wax images of themselves to put under the protection of Madonna of the Annuciation at her church, Santissima del'Annunziata, which George Eliot describes in *Romola*:

> The whole area of the great church was filled with
> peasant-women, some kneeling, some standing; the
> coarse bronzed skins, and the dingy clothing of the
> rougher dwellers on the mountains, contrasting
> with the softer-lined faces and white or red

head-drapery of the well-to-do dwellers in the valley, who were scattered in irregular groups. And spreading high and far over the walls and ceiling there was another multitude, also pressing close against each other, that they might be nearer the potent Virgin. It was the crowd of votive waxen images, the effigies of great personages, clothed in their habit as they lived: Florentines of high name in their black silk lucco, as when they sat in council; popes, emperors, kings, cardinals, and famous condottieri with plumed morion seated on their chargers; all notable strangers who passed through Florence or had aught to do with its affairs— Mohammedans, even, in well-tolerated companionship with Christian cavaliers; some of them with faces blackened and robes tattered by the corroding breath of centuries, others fresh and bright in new red mantle or steel corselet, the exact doubles of the living. And wedged in with all these were detached arms, legs, and other members. . . . It was a perfect resurrection—swarm of remote mortals and fragments of mortals, reflecting, in their varying degrees of freshness, the sombre dinginess and sprinkled brightness of the crowd below.

Perhaps the miniatures bored Zumbo. Perhaps rendering the subcutaneous territories fascinated him. For whatever reason, Zumbo dropped the vignettes and turned his hand to making anatomically perfect models of the human body in wax. He left for Bologna, met a group of renowned anatomists, and began his experiments with the help of a surgeon there, Guillemes Desnoues. Zumbo practiced his craft with corpses, modeling his *Anatomical Head* on the decapi-

Wax study of the superficial shoulder muscles and the subcutaneous vascular system.

tated one of an executed Genoa citizen. Never known for his placid temper, he broke with his colleague for reputedly laying sole claim as inventor of the wax anatomical model. As with most partnerships, each man felt that he had contributed the vision and intellect, keeping the other guy around just to perform the grunt work.

Zumbo left for Paris in 1700. Most documents concerning his last year of life reside with the French navy, which brought in corpses from the galleys to serve as Zumbo's models. The Versailles crowd immediately appreciated his contribution to science, and his rise in French esteem rock-

eted to its pinnacle when Louis XIV granted him a monopoly on all anatomical wax models. His physical rocket plummeted before he could enjoy his first period of financial stability. On December 22, 1701, the Sicilian died in his room on the rue des Cordeliers.

The humble reputation of wax and Zumbo's gruesome topic conspired to relegate his works to closets and cellars, and left some of them simply unattributed for the next 250 years. For example, the haunting beauty of the anonymous anatomical head at the Musée National d'Histoire Naturelle betrays Zumbo's genius. Louis XVII could have easily claimed rights to it at the sculptor's death, as with the property of any foreigner. Only in the last half of the twentieth century have art historians stooped to reexamine the tiny *teatrini* at La Specola and realized they are modeled not after decay but after Neapolitan painters Mattia Preti and Micco Spadaro and the inescapable Michelangelo.

Museo della Storia Naturale e la Specola

Via Romana, 17

Hours: 9 A.M.–1 P.M.; closed Wednesday. The zoological section is closed the second Sunday of the month.

Admission: L 6,000; L 3,000 for children and seniors.

Telephone: 055 2288251

Getting There: La Specola is practically next door to the Pitti Palace in Palazzo Torrigiani. To get to the Pitti Palace, cross the Arno River at Ponte Vecchio and walk straight down Via Guicciardini. To take a bus to the Pitti Palace from the train station, catch the D and get off at the Pitti Palace stop. Once in front of the Pitti Palace, walk away from the Arno on Via Romana and look for a modest plaque on your left.

The Stibbert Museum

The Stibbert Museum is part attic, part armory, part atelier, part anthropological exhibit, and part art museum. Altogether, however, it is a prismatic reflection of its founder and nineteenth-century resident, Frederick Stibbert. Stibbert came honestly to his taste for Asia and for armor. His paternal grandfather was a Scotsman who left Norfolk for Bengal. There he rose to commander in chief of the East India Company, and he married Sophronia Rebecca Write, an Anglo-Indian. Their son Thomas was born in India but wended his way back to Europe fighting Napoleonic campaigns, first in Egypt, then in Hannover, Copenhagen, and Spain as a lieutenant colonel with the Coldstream Guards. When the First Empire fell, Thomas moved to Florence and married Giulia Cafaggi. They had a son, Frederick, and a daughter.

Born in 1838 and dying in Florence in 1906, Frederick Stibbert lived during Queen Victoria's reign. He was educated first at Harrow and then Magdalene College in Cambridge, where he demonstrated little of the self-discipline and charm that later made him a successful collector. When he turned twenty-one in 1859 he came into the family's enormous fortune. He immediately returned to Florence and began life as a quintessential Victorian gentleman: indefatigable in traveling the world to buy costumes, porcelain, and furniture; fearless in transporting enormous bureaus and hauberks (chain-mail tunics) as well as delicate teacups from the Far East; gluttonous in his appetite for new and old objets d'art until the day he died.

Stibbert conducted an exotic life outside of England, and

outside the norm of his contemporaries, who bought paintings while he chose to examine cultures through costume and armor. As an Italian–Scotsman with a few pints of Indian blood, he presented a decidedly strange mixture to the xenophobic Brits. He even fought with Garibaldi's Trentino troops in 1866 during the war for Italy's unification and was decorated as a hero. Yet despite his eccentricities in both nature and personality, Stibbert lived and traveled firmly in the middle of society. The world's best drawing rooms welcomed him not only in London, but at least once a year also in Naples, Madrid, Paris, Moscow, St. Petersburg, Tokyo, and Peking.

Even Queen Victoria claimed him as an acquaintance. His villa abuts the Villa Fabbricotti, where Queen Victoria resided in 1894. A door at the end of Stibbert's garden, now bricked up, used to see the queen enter to continue her morning constitutional from Fabbricotti's park. When she visited the Villa di Montughi, she enjoyed standing on the balcony over her host's Sala dell'Armeria, where mannequins of cavalry soldiers seemed to prance under the flickering gaslights.

Stibbert collected from private residences, auction houses, dealers, and other collectors. He became known as a savvy financier in the international antique markets. The reputation might have stemmed only from his personal buyers assuring him, for example, that he had picked up the

seventeenth-century polychrome statues of Orpheus and Eurydice in Dusseldorf at a fraction of their worth. Making money at auction requires that one sell occasionally, which Stibbert obviously could never bring himself to do.

When he died, Stibbert's will left the museum and his estate to Britain, which turned the stuffed castle over to Florence in 1908. The city and the museum's trustees have both committed funds to restoring the castle and making it more accessible to the public; they have even added a few pieces to the collection.

Sometime after the Great War the trustees decided that the collection needed rationalizing or organizing along cultural and periodic lines. They have either given up or realized the error of their decision and are slowly returning the Fabrica di Montughi, as the building is called, to Stibbert's original arrangement. The rationale behind the turnabout lies in preserving the Stibbert Museum as a rare example of an authentic nineteenth-century residence-as-museum. However, the collection comprises 50,000 to 60,000 items in 57 or 58 rooms. Using modern math, even a rational system packs over one thousand not-all-small pieces into every room. The city must have realized that to sort just the armor into piles of seventeenth- through nineteenth-century swords, pistols, greaves, lances, shields, and helmets would require hiring Psyche's ants until the next millennium. Better to leave whimsical-enough alone.

For that is how Stibbert intended it. In fact, the entrance opens into what Stibbert in his own time had established as a museum. Beyond it is his private residence, also part of the tour. Joining a tour group is mandatory, given the number and smallness of the curios. Also, the museum is under constant reconstruction and reorganization—or

Florentine School, *Scenes from the Life of Antonio di Giuseppe Rinaldeschi.*

rather, re-disorganization—and as such pieces tend to move around, rooms that were once open are now closed, and vice versa.

The tour starts in the Sala della Malachite (room #2), which displays a microcosm of Stibbert's style and collection. The room is named after the green-black semiprecious stone that decorates the fireplace and a central Empire-style table, made for Jerome Bonaparte, that Stibbert bought from the royal Demidoff family in 1880 when they sold off their antiques.

Three tapestries in the Malachite Room include one of the finest pieces of the entire collection, the *Resurrection of Lazio,* woven in Brussels in the 1520s. Lined up against the wall is a mix-and-match of mid-sixteenth-century armor from

Germany, France, and Italy. Stibbert collected several rare hand-painted or -carved fifteenth-century chests, sometimes called *cassone*, that often served as hope chests. The one in this room, attributed to Francesco di Giorgio Martini (1439–1502) or his workshop, is considered one of the museum's greatest

treasures. An Etruscan helmet, one of the armor collection's oldest pieces, stands in a cabinet of headgear in the back.

The paintings reveal Stibbert's all-consuming interest in costumes. Given his enormous fortune, Stibbert could have bought paintings more critical to the history of art. He focused instead on what the sitters are wearing, especially if they are in uniform, rather than how well the artist manipulates his palette or draws a child's chubby cheeks. Not that they can be called bad paintings. For example, the Malachite Room's *Susanna and the Elders* and *Loth's Daughters* are two of the best by Luca Giordano (1634–1705), but he is a minor painter.

The next room that stays in most visitors' memories is called either the Sala della Cavalcata or dell'Armeria (room #9). The architect Cesare Fortini designed the neo-Gothic hall, while Gaetano Bianchi frescoed the walls. The room exhibits a European cav-

Crivelli, St. Catherine.

alcade of mannequin knights wearing a composite of uniforms from 1510 to 1630, as well as some samurai foot soldiers. The trustees tried and failed to rationalize the room, as they could not imagine the West and East marching together against a common enemy. Stibbert could and did.

Three Brussels tapestries, some of the most important in

the museum, show Hercules at his labors in subduing the fire-breathing Cacus, decapitating the nine-headed Hydra (with his nephew Iolaus cauterizing the wounds), and squeezing the giant Antaeus to death. Above the Armeria's entrance is a mounted figure of St. George that Stibbert designed.

The Cavalry Room also contains the funeral armor of Giovanni de' Medici "dalle Bande Nere" (1498–1526). The captain earned his nickname of "Black Bands" when he changed his banner stripes from white to black to mourn the death of his namesake, the Medici pope Leo X, who had assigned him his first troops to command. An Imperial shot wounded Bande Nere in a battle near Mantua, and he was carried to the Ducal Palace to die. Isabella d'Este's son Federigo Gonzaga buried him with state honors and completed his military shroud with a few Innsbruck pieces. Many thought the Medici war hero's death cleared the way for the Holy Roman Emperor's Sack of Rome. Bande Nere's ornate carapace thus symbolizes the end of the Italian High Renaissance.

From there, visitors enter what was Stibbert's private residence, with its cornu-copia of twelfth-century crosses, nineteenth-century French tables, Tuscan commodes,

Crivelli: St. Domenico.

porcelain perfume bottles, plates, and vases; eighteenth-century chairs, secretaries, tables, clocks, harps, mirrors, desks, and women's gowns; seventeenth-century painted spinets; fifteenth-century Madonna and Childs and Madonna and Child and Saints. Among the paintings to watch for is Carlo Crivelli's *Saint Catherine and Saint Domenico*, in which

the painter once more brings a book to life in the beautiful hands of a scholar. Nearby is the *Madonna and Child* attributed to Botticelli's school and sometimes to the painter himself. Franco Granacci's three scenes of Christ's death portray the tenderness between the women who loved him. Finally, the portrait of Francis I by Mirabello Cavalori (another Florentine, 1535–72) shows the face behind the man who designed the sixteenth-century infantry uniforms that Stibbert also displays. The Salone da Ballo exhibits a portrait of Stibbert painted a year before he died, at the age of sixty-seven.

At the end of the gallery is the 1890 blue-tiled Fumoir, or smoking room. Though the Italian *bottega* of Cantagalli made every piece of it, including the two huge majolica vases of fruit and vegetables, the ceramicist was married to an Englishwoman and obviously his workshop had come under the Liberty influence, or William Morris's version of Art Nouveau.

On the first floor both Stibbert's private bedroom and his mother's are decorated in the Empire style, which must have been their favorite period. His room is full of personal photos and paintings, and makes a show of his formal kilt. For some history buffs, the apex of the tour is the Sala Impero (room #50), which displays Napoleon's costume, complete with shoes, that he wore when crowned king of Italy in the Duomo in Milan in 1805. Its gold embroidered decorations include bees, the "N," sheaves of wheat, oak leaves as the ancient symbol of power, and on the left shoulder the emblem of the Grand Master of the Royal Order of the Iron Cross, which warns that it is God-given, and heaven help anyone who touches it.

The private residence's plethora of exquisite furniture and curios seems like merely gewgaws in comparison to Stibbert's armor collection, which obviously fueled the effort and

Dutch School, *Winter Journey.*

expense of his annual trips to the Far East. After his collection of spurs, Stibbert's display of Japanese military uniforms at the top of the spiral staircase in the Sale Giaponesi (rooms #55–57) is the second feather in his eccentric cap and can claim to be the best outside of Japan and the Metropolitan Museum.

At the turn of the seventeenth century, Japan unified under the Tokugawa shogunate, which maintained 250 years of somnambulant peace. The Edo period's military uniforms thus lightened in weight and spirit. Ranging from the sixteenth to the nineteenth century, the Japanese helmets alone justify a trip to the Stibbert. They sport birds' and rabbits' heads, elk horns and octopus tentacles, decorative fans, and entire cranes, snakes, carp, and dragons. The rooms (6 and 7)

containing the other Eastern military paraphernalia are at the bottom of the spiral staircase and include uniforms from the fifteenth-century Turkish army, as well as from the Persians and Indians.

Outside, Stibbert's park invites weary visitors to recuperate by walking along its landscaped paths. The garden combines Italian and English traditions that Gerolamo Passeri designed between 1859 and 1880, with Giuseppe Poggi adding such touches as the lemon house and Egyptian temple, as well as the artificial lake. The park extends naturally to the Villa Fabbricotti's grounds.

Stibbert Museum

Via Stibbert, 29

Hours: 10 A.M.–2 P.M. Monday–Wednesday (the last ticket is sold at 1 P.M.); 10 A.M.–6 P.M. Friday–Sunday (the last ticket is sold at 5 P.M.); closed Thursday.

Admission: L 8,000. *Caution:* available only through the museum's guided tour, which starts on the hour and lasts an hour.

Telephone: 055 475520

Getting There: From the train station, catch the #4 bus to Vittorio Emanuele II. Walk up Via V. Emanuele II to Via Stibbert. Walk up the steep incline on Via Stibbert. (If you have a car, park it on Vittorio Emanuele.) The museum is on the right side; across from it stands the medieval Chiesa di San Martino a Montughi.

A Knight of Malta. Frederico Stibbert's sketch of an anonymous painting that he copied from his collection.

The Bomarzo Garden

Deeper and deeper, of the secret wood
He penetrates the tangled mystery.

—Ludovico Ariosto,
Orlando furioso, XLV, 92

The method behind the madness of the Bomarzo garden lies buried deep in its Renaissance roots. Pier Francesco Orsini commissioned the architect Pirro Ligorio (1514–83) in 1552 to create the garden of grotesque mythological sculptures, which they called Villa of Marvels. A change in power had forced Ligorio to take a break from his masterpiece, the Villa d'Este in the Tivoli Gardens outside of Rome. Though he had not even begun the Arcade of a Hundred Fountains, for which the Tivoli Villa is best known, the architect, scholar, and polymath had already revolutionized the art of landscaping. He defined the archetype of Italian gardens and determined the appearance of great estates throughout Europe for the next two centuries, until Versailles usurped the throne as the most modern of gardens. During his breather at Bomarzo, he worked with Orsini until 1564, when the Vatican asked Ligorio to come help replace Michelangelo, who had just died—not a request anyone could turn down easily. Ligorio left the Duke of Bomarzo to his garden, which fell into disrepair until Giovanni Bettini and his family rescued it from obscurity in 1954.

Art historians have a duty to discover the underpinning philosophy of all they study, but the sculptures at the

Bomarzo are the *New York Times* crossword puzzle of artworks. Figuring out the themes and fitting them all into a neat square is best done with pencil.

Here is the list of characters: Stepping into the garden, visitors stop between two sphinxes. The one on the left takes the doubters to task immediately: "The supercilious and the tight-lipped will not enter here without being astonished by one of the Seven Wonders." The right-handed one says, "You who enter of two minds can tell me if the many wonders here were made in folly or as art."

Take a left, and a foursome of Saturn, Janus, a faun, and three-faced Hecate smirk or grimace. They guard the figure of Proteus, the sea monster who changes his shape at will, or perhaps it is Glaucus, a humble fisherman who transformed himself into a sea god. In either case, the ball and tower that the leviathan balances on his head remains a mystery.

Turn back past the sphinxes, wonder at the ambiguous ruin with a few figures etched in it, and admire on the left Hercules fighting Cacus as the nearby waterfall pours its heart out to make the sound effects.

Step down and keep to the right on the terrace to see the tortoise carrying winged Victory. At the bottom of the ravine a whale gasps, wondering what he is doing so far from sea. Look up at Pegasus, who is launched for winged flight, probably to visit the Three Graces that stand etched in a shrine farther on. On the left is a goddess of love; farther still, a theater.

On the right leans a house built specifically to befuddle visitors four hundred years too early to read *Alice in Wonderland* and understand the tilting, jolting, astonishing labyrinth their host had designed just for them. Neptune looks sadly over a dry pool, and Ariadne sleeps on her Naxos rock, her Cretin hands and feet too enormous for love, or so she dreams.

Ligorio, *Sphinx,* which lies on a tablet addressed to the "supercilious and tight-lipped."

Turn back past Neptune toward the steps, and on the left sits Ceres, or Demeter to the Greeks, mother of Persephone and originator of the seasons. One of the garden's finest sculptures, she balances an urn on her head and smiles softly at another beast of burden, an elephant that carries a tower not made of ivory. His trunk either caresses or crushes the Roman legionnaire slouched against his chest who sets the mold for Pinocchio three hundred years in advance. Next, a dragon laughs in the face of a dog, a lion, and a wolf, a vignette that the architect claims represents eternal time against the past, present, and future. (Ligorio made many explanatory comments on the sculptures that, like hints to the *Times* crosswords, serve more often to obfuscate than to illuminate.)

On the right, Orcus of the underworld screams, "Every thought flies," a true prophecy when one enters and sits at the stone table and seat. On the left is a giant vase, and farther on a beast and an Etruscan bench.

Head up the first steps, which Cerberus guards, all three of his canine heads more contemplative than usually portrayed. Turn left and Proserpina, as guardian of the underworld, offers a bench to those traveling through Hell. Actually, the sculptures as neighbors in Hell might prove the most consistent explanation yet for what ties together all the characters.

In front of the goddess stand two bears, three-dimensional replicas of the Orsini (bears) crest, and ahead lies Echidna, Cerberus's mother. I have never seen an artist give the dog his serpent's mane and tail, which he inherited from the half-woman, half-dragon. She bore such monstrous children that three of them—Cerberus, the Hydra, and the Nemean Lion—challenged Hercules in his Twelve Labors. A lion lies in the shade beyond Echidna, who like her son the Nemean has impenetrable skin and comes from the Viterbo coat of arms.

Flinging open her wings and thrashing her dolphin's tail against the lion is Mania, the Etruscan goddess and guardian over Hell. Her companion Mantus is the mythological founder of Mantua. She is also a goddess of the earth, and she carries a basket on her head for the harvest.

Such is the cast of characters. Now who is their author? The elephant makes some suspect that the bizarre and grotesque statues represent Hannibal's journey across the Alps, but where do the tortoise and his Victory companion fit in? *Orlando furioso* pops up often as an explanation, and Ludovico Ariosto does mention that Orlando fought like Hercules against the giant Cacus. But Orlando vented his fury as a cavalier should, from his horse, and not from the ground like the Bomarzo Hercules. Even stringing disparate sagas together fails to encompass all the sculptures, some of which are ambiguous in any context.

Ligorio, *Hercules Fighting Cacus* near a peaceful brook. A simple depiction of the legend's conquest of a giant or a reference to *Orlando furioso* and his battle style?

Scholars and casual observers agree that the garden must illustrate a saga of danger, good fortune, helpful and dangerous gods, and fortunes told and made. Orsini claimed that mourning his wife's death gave him the impetus to build the

park, which he planned *"sol per sfogare il core,"* only to relieve his heart. The Italians use *sfogare* both to "pour out" their hearts and to "vent" their rage, and the double meaning applies well to the manic-depressive theme in "Monster Park." After all, the prince's rationale and the scholars' theories do not necessarily contradict each other. Love is a torturous journey, full of hopeful portents and dashed hopes, heroic fights and calm muses, sphinxes and ogres. While the duke's sculptures indubitably spring more from his whimsy than from any dogmatic program of literature, they all speak of his love for his wife of twenty years, and express his lifelong sorrow and rage over losing her.

Ligorio, Proteus the monster fish or Glaucus, a fisherman transformed into a sea god?

Bomarzo Garden

Hours: 8 A.M.–sundown.

Admission: L 15,000

Getting There: From Florence toward Rome, take Autostrada A1 south toward Rome, 184 km to the exit for Bomarzo (28 km south past the Orvieto exit). Take the small road southwest toward Bomarzo and follow the signs for Parco dei mostri.

From Rome, take Autostrada A1 north toward Florence, 73 km from the G.R.A. to the Bomarzo exit (12 km north past the Viterbo/Terni exit). Take the small road southwest toward Bomarzo, and follow the signs for Parco dei mostri.

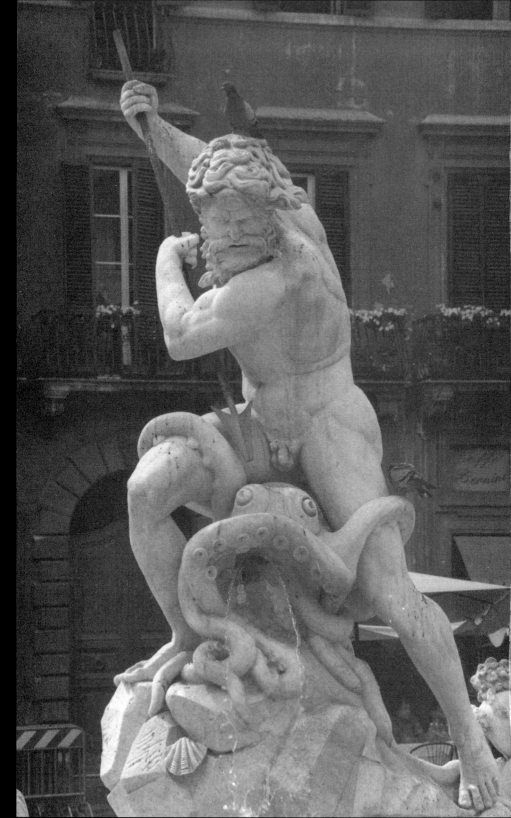

Rome

Italian must be the easiest language in the world to learn. Italians are for the most part excellent teachers in that they willingly talk to foreigners and illustrate their points with hand gestures that are gracefully articulate. They will speak slowly and repetitively, and eventually the thick skull that most mortals wear to guard against foreignness will thin and absorb the language's rudimentary phrases.

A trick for passing as an Italian conversationalist is to learn the vocabulary for three subjects: food—what one ate last night and today, and one's plans for tonight; whether the mountains or the beach is better for an August vacation; and which is the superior city, Rome or Florence.

For those who prefer Florence, Rome is an unmitigated mess, confused, noisy, dirty, chaotic, and altogether a *casino*, which is a particularly uncomplimentary description, referring to a gambling house at best, a brothel at worst. For those who prefer Rome, Florence is a museum, a relic, a carapace.

The most avid *Romani* agree, however, that the city overwhelms even those with thighs of steel who hurry up and down the seven hills and with well-engineered feet to walk the miles of museums that the very basic tour entails. Visitors also need the attention span of Jupiter on his three-hundred-year honeymoon with Juno to admire one piece of art after another after another. The city is not tidy and self-contained. Maps are huge, and streets wind around with absurd names like the Viale Giorgio Washington and the Lungotevere Arnaldo da Brescia, which even when abbreviated fit on a map only if

printed in two-point type. Those who can afford the city's inflated prices usually could last read such tiny letters twenty years ago.

Despite its inconveniences, the Eternal City packs in the tourists, and provides weeks of sight-seeing for those with such specialized interests as ancient history, archaeology, theology, paganism, art history, landscape design, and the latest fashions in handbags. All must bring comfortable shoes and sun hats and the energy of teenagers to see everything in what is inevitably a strictly proscribed amount of time.

Of Rome's history, its contemporary problems, its art and architecture, one needs an entire book just to absorb the outlines. However, like an advice columnist with three inches in which to prevent a supplicant's divorce, I can offer a single word of guidance to avoid disaster: Prepare. The Internet offers thousands of pages that list bus routes, tram schedules, instructions on how to mail letters from the Vatican, warnings about mailing packages from the Italian post office, suggestions for the best time to visit the Galleria Borghese, and everything else one could possibly need to know. Mainstream guidebooks, which might be more dependable but also dated, contain plenty of useful information. Like the man who wears both suspenders and a belt with a particularly baggy pair of pants, you might supplement your guidebook with a few pages from the Internet just to assure yourself that you bear the most accurate and current information.

After you arrive, a useful mantra is, Relax. My husband is a scientist and pilot; the combination makes him extremely punctual. When I first took him to Italy, I warned him we were joining a culture that is more interested in finishing lunch with decorum than in returning at an appointed time. Relax when the bus that is supposed to take you to the

Vatican does not show up for an hour because of the *sciopero*, or "strike," a word almost as important to know as *chiuso*, or "closed." One of my favorite memories is of waiting at a stop for a bus that never came and talking to an elderly woman— or being talked at by an elderly woman—who taught me the phrase *il bel tramonto del sole* ("beautiful sunset"), which it truly was.

Patience is always the key to enjoying Rome. Sometimes more is needed. If you must go to the Italian post office, take your rosary or your "Sayings of Buddha" with you. Not that Rome has failed to notice the advent of capitalism and its sensitivity to ticking minutes. Dinner in Rome is much more rushed than it was twenty years ago, when waiters wrote down the *primo*, then returned half an hour after the diners had scraped up every bit of minestrone to take orders for the *secondo*. Yet it is still glacially slow when compared with most countries outside of the Mediterranean. When in Rome, eat as the Romans do.

But do not drive as the Romans drive. The contrast between Romans behind the wheel of a car and in front of a dinner plate bewilders many visitors. The Romans drive at suicidal speeds—suicidal for the pedestrians trying to cross four lanes of traffic to Piazza del Popolo—yet have the countryman's patience for the passage of time when travelers checks need to be changed, packages need to be sent, or luggage needs to be hauled up to a room designed for anorexic models.

Finally, taking the historical view will help in surviving Rome. One of the best tours of ancient Rome is on Trolley #3, which also gives an overview of the city for a mere L 1,500. Pick up the #3 (*not* #8) at the neoclassic palazzo of the Institute of Public Education (Pubblico Istruzione) on Viale

Trastevere. The #3 goes past Circo Massimo, the Palatine Hill, and Gregorio Magno, then up for a great view of the Colosseum and Colle Oppio, and on to San Giovanni in Laterano. Stop at Prima Porta, the gates to ancient Rome. The trolley has toured you through what is merely the city's armature, to which architects have been adding ever since it was built. Rome has been unmanageable for four thousand years. Don't let it spoil your trip.

Sant'Ivo alla Sapienza

When Gian Lorenzo Bernini (1598–1680) hired Francesco Borromini (1599–1667) as an apprentice to help in St. Peter's,

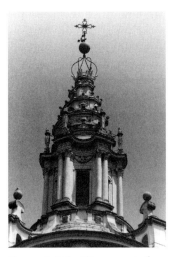
Borromini: Sant'Ivo campanile.

he invited a rival who pestered him for the rest of his life. Though always the more powerful of the two and an internationally admired sculptor, Bernini as an architect was Borromini's inferior. Sometimes relegated to accepting Bernini's crumbs—as when the sculptor recommended Borromini as the architect for the Sant'Ivo, church to the University of Rome— Borromini depended on his own creativity to force beauty into Rome's smaller spaces. His imagination led him to such innovation that many architects revere Sant'Ivo alla Sapienza as one of their favorite Baroque spaces, inside and out.

Borromini inherited a plan—build a circular church— from the time of Clement VIII. The Palazzo della Sapienza's

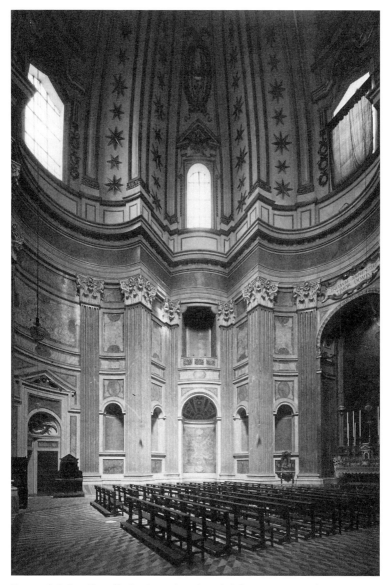

Borromini, Sant'Ivo alla Sapienza interior of tight convexes and concaves.

elegant and spacious court is of a university founded in 1303 that now contains the State's archives. The commission of a university's rather than a parish's church liberated Borromini from many of the Baroque conceits, such as an extravagance of crosses and colored marble. The architect worked on Sant'Ivo from 1642 through 1660, when Alexander VII consecrated the church. Borromini showed both restraint, in honor of the church's scholarly attendees, and fantasy in the church's internal and external contours.

Like an origami master who folds and unfolds stone instead of paper, Borromini starts with a simple shape, the equilateral triangle, which symbolizes *sapienza,* or wisdom. The church is often called Domus Sapientiae, House of Wisdom. He doubles the triangle, twists the ends, performs a sleight of hand, and unfolds six convex bays on each point to support the cupola. The interior spins in tight curves and circles. To keep the attention on his manipulation of space and not on the details, Borromini decorates the wavelike walls modestly with symbols of Pope Alexander's Chigi family— gold eight-point stars and mountains—as well as cherubim and palms set against a white background. The understated interior is a startling relief after the usual Baroque madness for green, red, pink, and blue marble one finds in Rome. The gold-lined dome is the focal point for the entire marvel of undulating light.

Outside, Borromini had to work around the courtyard's existing concave facade. He balances it with the dome's large convex bays and echoes it with smaller concave ones. The spiraling campanile came to Borromini in a dream in which he imagined the Tower of Babel with its circular waterfall; of course, he might also have dreamed it after seeing sketches from the newly explored city skylines of India. On top of the

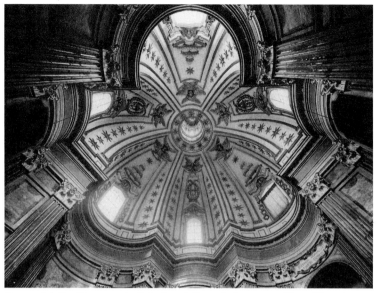

Borromini, Sant'Ivo cupola, interior of the spiral crown, with putti and symbols of the Chigi family.

exotic steeple a flaming crown "smokes" delicate wire tendrils that billow out, then wrap back together to support a globe and cross.

The architect intended the internal to meld with the external. As Paolo Portoghesi points out in *The Rome of Borromini: Architecture as Language,* the adventurous can climb to the spiral "through a vertical shaft that opens into a cell at its base. The edge of this spiral crown serves as a railing for the narrow corridor that leads up to the metal cage about the flaming crown. Making this ascent one necessarily observes and touches the ornaments on the edge of the crown"—not a necessity that today's visitors should attempt.

While the chances of climbing up and seeing the city from this splendid vantage point are nil, the chances of getting into the church have increased in recent years. When standing on the ground floor, one can still remember that

Borromini intended us not only to gaze up into the cupola, but also to look down through its cloverleaf frame at the church's floor plan. From this vaulted perspective the concave bays pirouette around what is both the Star of David and the symbol of the Holy Trinity, and only then can one see Borromini's stark illustration of how religious ecstasy depends on a solid foundation of knowledge and study.

Sant'Ivo alla Sapienza

Corso Rinascimento, 40

Hours: 10 A.M.–noon on Sunday, or ask at the care-taker's. Closed July and August. The church seems to be open more often, especially in the morning, and is well worth walking by to check.

Getting There: Sant'Ivo is located near Piazza Sant'Eustachio. The entrance to the courtyard of Palazzo della Sapienza is on Corso Rinascimento between the south side of Piazza Navona and the Pantheon. Many buses stop at Corso Rinascimento; ask to be let off at the Senate *(il Senato)* or Palazzo Madama.

From Piazza Navona's south end, walk down Via di Pasquino, cross Corso del Rinascimento, and enter an inconspicuous open doorway on a plain wall. From Piazza Navona's north side, cross Corso Rinascimento, then walk past the Palazzo Madama (the Senate) going south, and you will find the Palazzo della Sapienza.

From the Pantheon, head west through Piazza Sant'Eustachio and you will be in the back of Sant'Ivo, looking at a section of its curves.

The Alexandrine Library in the Palazzao della

Sapienza is also Borromini's work, in which he creates a chiaroscuro of white pilasters that support a narrow balcony, and wreath- and star-topped dark bookcases.

The espresso at the Caffé Sant'Eustachio is famously good. Should you mention this to the *barista* at the café nearest your hotel, however, he will assure you that his coffee is superior because the aquifer is sweeter on his street than on any other street in Rome, including the one feeding Sant'Eustachio.

The Mithraeums

Mithras born of a rock and out from the cave becoming sol invictus *and turning the wheel darkness, now a fading memory.*
—Rudyard Kipling, "Yule"

Bearing a name that means both "contract" and "friendship," Mithra is an ancient Persian god whom the Romans worshiped from the first to the fourth centuries A.D. Some of the cult's traditions and mores we have retained, such as shaking hands when meeting friends or agreeing to a contract, pledging monogamy in marriage, wearing crowns, and celebrating December 25 as the birth date of an all-powerful god.

Rome concentrates in one city the greatest number of mithraeums, or Houses of Mithra (just as museums are houses of the Muses). They served as houses of worship, rather than just altars where worshipers left offerings. Instead of being satisfied with mere altars, Mithra followers gathered regularly in underground rooms for ceremonies, sacred meals, initiation rites, and everyday communal prayers and recitals of the liturgy.

Ostia Antica, where many of the best mithraeums are seen when not under restoration.

Rome's mithraeums and their relics are hidden in church basements, in caves, and on back shelves. To see them sometimes requires making reservations and presenting academic credentials. As Christianity's main competitor in the first through third centuries A.D., Mithraism seems as successfully repressed today in Rome as it was a millennium and a half ago.

During his Roman era, Mithra spawned an international religion among the lowliest to the highest factions of male society. A plot of Mithra's temples crosses the globe like a ribbon, stretching from modern-day Israel northwest to Scotland, tapering at its ends and bulging at Rome. Most excavated mithraeums concentrate in Rome, east to Romania, north to the Rhine, and around Vienna and the Danube; in short, all of Continental Europe. Until the West adopted Christ and the Persians switched to Allah, many in both areas revered Mithra.

With roots at least 2,400 years old in Iran, the Mithraic

cult entered the Western Hemisphere when Alexander the Great conquered the Persians in 334 B.C. at the beginning of his epic march through Asia Minor. The Greeks never embraced Mithra's cult, as it symbolized their centuries-old enemies, the Persians, and thus the god cannot be said to have become part of the West's culture until 67 B.C. According to Plutarch, writing in 75 A.D., the emperor Pompey conquered the pirates who came from Cilicia, a narrow strip of land along what is today the southwest coast of Turkey, from Syria to the point of Rhodes. They "celebrated certain secret rites, among which those of Mithras continue to the present time, having been first instituted by them."

When Mithra arrived in Rome, he had changed guises from his Persian original. The small, hot melting pot of Stoic intellects living at the base of the Taurus Mountains transfigured Mithra by interpreting new astronomical data about how the stars are not immutable. Mithra came to symbolize either Perseus or Orion, and his Roman-centered cult looked to worship him according to the sun's and stars' movements.

Mithra's ascent in Rome exactly paralleled that of Christ, and their followers fought each other to control a central religious power. The Christians won. Mithraism plummeted quickly after Constantine the Great (280–337 A.D.) converted to Christianity in October 312. Thus, in the beginning of the fourth century one could be martyred for practicing Christianity and by the century's end one could be martyred for not.

The fourth century brought many changes to Christianity, too. The sect decided to avoid harassment from other cults by celebrating Jesus' birth on December 25 and thus sharing it with Mithra.

Constantine had envisioned monotheism replacing the

cacophony of Greek and Oriental cults that made Rome a religious Tower of Babel. He thought the god would combine Mithra and Christ. They were the strongest religions, despite both originating from the East (Christianity at that point was considered no more than a brand of Judaism). Instead, Constantine's death ignited religious wars. In retaliation for centuries of persecution, zealous Christians strewed garbage into and filled up mithraeums, smashed sculptures and paintings (as in the St. Prisca mithraeum), harassed the cult's followers, and occasionally murdered its high priests. The end of the fourth century saw the end of Mithra worship.

The Myth of Mithra

While Mithra worshipers were sworn to secrecy concerning the cult's core liturgy, and the rituals, prayers, and organization are today merely educated guesses, the myth itself is well known. Mithra is born of a rock, full grown, naked except for a Phrygian cap and a cape, and carrying a knife and a torch. He becomes friends with the sun god, Sol. Sol sends a raven to Mithra commanding him to sacrifice the bull, one of the only creatures on the thinly populated earth. With his dog to witness his reluctance, Mithra hunts down the mountain-sized beast. Sculptures portray him turning his head away in grief as he straddles the bull, grabs its nostrils, and plunges a knife into the helpless creature's shoulder. Even the wound's location is a sign of Mithra's distaste for his assignment, for stabbing a bull in the flank will not kill it. Wheat springs from the wound, and all of creation sprouts from the river of blood. The dog and a serpent leap to lick the blood, while a scorpion clings to the dying animal's genitals.

Afterward, Mithra shakes hands with Sol, and they recline

together at a table in what is referred to as The Last Supper. They break bread and drink wine together, then Mithra rises in a chariot with the sun god, threads his way through the

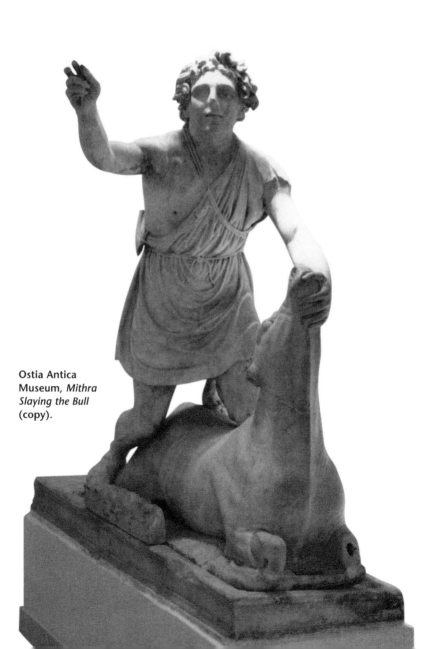

Ostia Antica
Museum, *Mithra
Slaying the Bull*
(copy).

twelve planets, where he discards any impurities of character, and resides in eternal bliss in heaven among the stars, which, unlike our own fickle constellations, are indeed immutable.

The Rituals

Only a few fragments of the prayers and liturgy exist— imagine if every New Testament were burned; we would know Christianity's hymns and Scripture only from quotes inscribed on church walls and would guess at its rituals from Judaism. We do know that initiates entered new levels bound and blindfolded and were tested by fire and water. Mozart

Ostia Antica Museum, *The Death of Ulysses.*

opera fans can easily imagine the initiation ceremonies as a derivation of the last act of *The Magic Flute*, including huge male choruses singing in baroque, gold-colored costumes. Originally the rituals shed hair-raising amounts of the *milites'* blood. Later the Paters or priests muted the more barbarian tests, perhaps to appeal to the Roman elite. By the third century, the Mithraic cult orchestrated elaborate games of blind-man's bluff to test supplicants' faith in Father (Pater) more than their physical courage under torture.

The everyday ceremonies involved first the Pater's sacrifice of a small animal or bird to symbolize the slaying of the bull. Symbolizing the most powerful deity, superior even to

the Sun, the Pater then crowned the kneeling representative of Sol (Heliodromus). The crown represented the Roman laurel wreath shot through with the sun's rays. The Pater and the Heliodromus next conducted the liturgy together. Finally, they officiated over the sacred meal, as the lesser Mithraites served them and those closer to them in rank.

Where the temple's founders had made room for it, the Mithraites evidently started certain ceremonies with the ritualistic slaying of a bull, the taurobolium. Probably the Pater reserved the taurobolium for special occasions, such as Mithra's birthday. In some cellars, the bull lay bleeding over a grate while Mithraites lay on the floor below as the blood washed them clean of their sins.

Or is this merely a nasty rumor? The victorious write history, and the early Christians wrote about the Mithraic atrocities as propaganda against the "evil" cult. The Mithra followers' insistence on secrecy left them vulnerable to terrible accusations. While they certainly performed taurobolia in Rome, particularly at the Baths of Caracalla, the location of most mithraeums in Rome and Ostia would have meant pulling a bull, no small feat in itself, into narrow alleys and through the living rooms of private houses. The mithraeums themselves were seldom more than six feet wide. Squeezing in the cult's members and a ton of savage animal would have required divine intervention, not to mention a sack of valerian for the bull.

What a Mithraeum Looks Like

Usually, mithraeums can contain no more than fifty people. They are underground, though they sometimes have holes that allow illumination of part of the temple during the

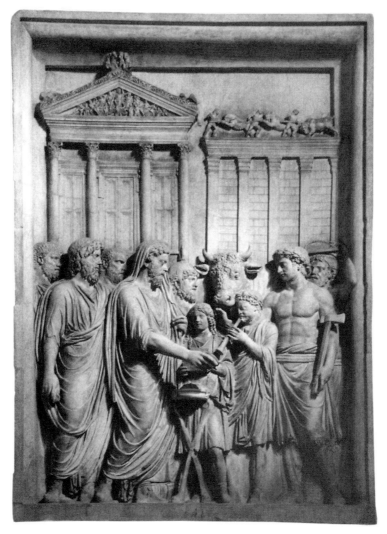

Palazzo Bernini, frieze depicting the sacrifice of a bull.

equinox, for example, or from which one can spot certain
stars during the year. Worshipers enter from the back, one at
a time. They sit or recline on benches along the side in order
of rank: those who have passed through four to six stages of

initiation sit closest to the altar, which is in the front, where the priests sit. The initiates serve those who recline. The altar, which makes up most of the existing Mithra relics, was either painted with bright colors or held a sculpture or, unusually, a stuccoed relief of the Mithra *tauroctony,* the term for the god slaying the bull. The god stands between Cautes, who bears a torch upright, and Cautopates, whose torch is upside down; they represent the rising and setting of the sun. His dog and the snake lap up the bull's running blood; the scorpion clings to the animal's testicles; a raven stands above Mithra; sometimes a cup is present, as well as Sol and Luna. The animals represented different truths according to the followers' level of initiation into the religion. To a beginner, for example, the bull might symbolize the earth dying in winter to give new life in the spring; to the priest, the bull represents the constellation Taurus and its ancient role as harbinger of the spring equinox. For all, the animals reflected the military values of honesty, courage, and trust-worthiness.

How to See the Mithraeums in Rome and Ostia

One way the Church successfully repressed worship of Mithra was by building churches over the mithraeums. St. Peter's Basilica, for example, sits on a foundation of blood from the last Roman taurobolium, which took place at the end of the fourth century in what was the Phrygianum. Ironically, burying the mithraeums underground kept them intact for the twentieth century's flurry of excavations, so that some of Rome's best-preserved Mithra temples are in church base-ments. New ones are still being found, such as one discovered during excavations in the Crypta Balbi. The mithraeum itself

is still being dug out and is not yet open to the public.

St. Clemente is the most accessible mithraeum in the city. It takes you deep into the bowels of Rome, past houses that burned while Nero fiddled. Through bars one can see the altar of Mithra performing the tauroctony.

The Mithraeums of Ostia Antica

Some of the best mithraeums lie outside Rome in Ostia Antica. However, they are often difficult to find. Ostian slaves and shopkeepers established mithraeums in the most humble of neighborhoods, often near the warehouses and docks where they worked. As a result, except for the ones at the granary (Horrea) and the House of Diana, the mithraeums are scattered evenly all over the miles of ruins.

Once discovered, most of the mithraeums in Ostia are locked up, such as the House of Diana mithraeum, or in some way made inaccessible. For example, the mithraeum at Felicissimus has always been a favorite of archaeologists. Its mosaic shows the symbol for each level of initiation into the cult, as well as the gods that protect the initiates, and their corresponding element. One arrives salivating slightly from the long walk and the anticipation of finally seeing what photos cannot do justice to, only to find that sand completely covers the mosaic as it is restored.

Ostia Antica Museum,
Mithra Born of a Rock.

St. Clemente Basilica, Mithra temple.

Two accessible mithraeums are at the Baths of Mithra and the House of Apuleius, which contains a life-size sculpture of Mithra. Only by purchasing a map will you find them, and even then you must be part Eagle Scout, part hound dog to sniff out the underground temples.

I can only suggest that you hire a guide for a few hours (L 50,000). Even if you do not speak Italian, find a way to ask to be shown the Mithra. (Showing photos from this chapter should do the trick.) It will save you from hopeless searching among the knolls and winding pathways of what was once a teeming city.

My own guide, who had retired from managing Ostia Antica's security, took me rapidly to the largest and most impressive mithraeum, forcing me to trot behind as he plunged his cane confidently in a direct path. Meanwhile, an American couple wandered helpless somewhere above me

looking for the House of Cupid and Psyche, which the guide
had already told me was *chiuso*.

Mithraeums Open to the Public

The list below provides current information on what can and
cannot be seen. Check with tourist centers, such as major
hotels, about joining tours.

San Clemente

Via San Giovanni in Laterano

Hours: 9 A.M.–12:30 P.M. and 3:30–6:30 P.M.; on holi-
days 10 A.M.–12:30 P.M. and 3:30–6:30 P.M.

Admission: L 4,000.

Getting There: Take a bus or the metro to the
Colosseum (Coloseo). Via San Giovanni in Laterano is
directly to the east of the Colosseum. If you are arriving
on the metro, get off and walk straight around the
Colosseum. San Clemente is on the left.

A medieval basilica, San Clemente opens only parts
of its mithraeum; the Mithraic school, which has
mosaics and stuccoed walls, is closed to the public.
The barrel-vaulted, late-second-century to early-third-
century mithraeum, with benches on either side, is
locked up. Through the bars, one can see the major
tauroctony sculpture, but sometimes another Mithra
sculpture is missing that should stand in the niche
behind the altar.

Mithraeums in Ostia (Scavi di Ostia Antica)

Viale dei Romagnoli, 717
Roma 00119

Telephone: 06 56358099

Fax: 06 5651500

Hours: Tuesday through Sunday, 9 A.M.–7 P.M.
April–September, 9 A.M.–4 P.M. October–March;
closed Monday.

Admission: L 8,000; free to those under 18 and over 65.

Getting There: The best way to get there is to take the
metro (Ferrovia Roma-Lida) from Porta San Paolo. To
get to San Paolo, take Line B from the train station
(Stazione Termini). The train leaves from San Paolo
every 15 minutes and takes you to Ostia Antica in 35
minutes. Take the footbridge directly to the museum
and ruins. Also, you can bring a swimsuit and return to
the train to go to Ostia Lido, which is Rome's nearest
beach resort. The Stazione Termini also offers a train to
Ostia Antica, but it does not run as often as the one to
San Paolo.

Ostia Antica, shop mosaic of driving a bull to slaughter.

Places to See by Writing or Calling for Permission or
Attending a Tour

Mithraeum of the Baths of Caracalla

Write for permission to:

Soprintendenza Archeologica di Roma

Piazza Sta. Maria Nova, 53

00185 Rome, Italy

Telephone: 06 6990110

Fax: 06 6787689

Santo Stefano Rotondo

Via di Santo Stefano Rotondo, 7

As of 2001, the mithraeum was temporarily closed for
restorations.

Hours: Monday–Friday, 9 A.M.–noon.

Telephone/fax: 06 7593717 for a special permit.

Mithraeum of Circo Massimo

Permission required from the Soprintendenza di Roma:

Soprintendenza Comunale

4 Dipartimento

5 Unità Organizzativa

Via del Portico d'Ottavia, 29

00186 Rome, Italy

Telephone: 06 67103819

Fax: 06 6892115

Getting There: The Circo Massimo mithraeum is located
on Via dell'Ara Massima di Ercole (to the left, next to
Santa Maria in Cosmedin).

Mithraeum of Santa Prisca

Permission required from the Soprintendenza di Roma:

Soprintendenza Comunale

4 Dipartimento

5 Unità Organizzativa

Via del Portico d'Ottavia, 29

00186 Rome, Italy

Telephone: 06 67103819

Fax: 06 6892115

Mithraeum of Palazzo Barberini

On the back of the palace an ancient temple, called the Mitreo Barberini, was dedicated to Mithra. It is a narrow hall with paintings of Mithra's life. Write for permission to:

Soprintendenza Archeologica di Roma

Piazza Sta. Maria Nova, 53

00185 Rome, Italy

Telephone: 06 6990110

Fax: 06 6787689

Mithraic Artifacts

Capitoline Museums

Relics from Rome's Mithra cults, especially from San Stefano, are not yet on display in the newly renovated and still-in-progress Capitoline Museums. They are stored in the room to the left on the ground floor of the Palazzo Nuovo, but the collection is being reorganized.

Baths of Diocletian (Terme dei Deocleziano)

Viale Enrico de Nicola, 77 (entrance in front of the
 Stazione Termini)

Telephone: 06 488 0530

Hours: 9 A.M.–7:45 P.M. (ticket office closes at 7),
 Tuesday–Sunday. Closed Monday. Open 9 A.M.–11 P.M.
 on Saturday, June 15–September 15.

Admission: L 8,000; the ticket is also good for the
 Museo Nazionale Romano. A single L 30,000 ticket
 will get you into the Baths of Diocletian, the Museo
 Nazionale Romano, the Palazzo Altemps, the
 Colosseum, and the Baths of Caracalla.

Getting There: Many buses and the metro stop at this
 huge square. It is within walking distance of the train
 station.

 The Mithra relics in the Museo Nazionale are on the
 second floor in the Octagonal Hall of the Baths of
 Diocletian.

Museo Nazionale Romano

Palazzo Massimo

Piazza dei Cinquecento

Telephone: 06 488 0530

Hours: 9 A.M.–5 P.M.; Sunday 9 A.M.–1 P.M.; closed
 Monday.

Admission: L 10,000; the ticket is also good for the
 Baths of Diocletian. A single L 30,000 ticket will get
 you into the Baths of Diocletian, the Museo Nazionale
 Romano, the Palazzo Altemps, the Colosseum, and
 the Baths of Caracalla.

Getting There: Many buses and the metro stop at this huge square. It is within walking distance of the train station.

The National Museum now shows the collection of inscriptions of the museum as well as a whole wing on early Rome and Latium. On the second floor, relics from the Mithra cult and also those from the Syrian gods, found on the Gianicolo, are on display.

Vatican Museums

Viale Vaticano

Telephone: 06 69884466

Hours: From April 1 through October 31: Monday–Friday 8:45 A.M.–4:45 P.M.; the ticket offices close at 3:30 P.M.. Saturdays and the last Sunday of the month, 8:45 A.M.–1:45 P.M.; the ticket offices close at 12:30 P.M. From November 2 through March 31: Monday–Saturday, 8:45 A.M.–1:45 P.M., the ticket offices close at 12:30 P.M. Closed Sundays except for the last Sunday of the month. Closed Vatican holidays: January 1 and 6, February 11, March 19, Good Friday, Easter Sunday and Monday, May 1, Corpus Christi Day, June 29, August 14 or 16, August 15, Ascension Day (a Thursday), October 16, November 1, December 8, 25, and 26.

Admission: L 18,000. Students under 26 years of age with a valid student I.D., L 12,000. Children under the age of 14, L 8,000. Discounts available to groups of students whose schools write in advance on letterhead. Free to pilgrims with a letter from their local diocese. Free to the disabled and a companion. Free the last Sunday of the month and September 27.

Getting There: From the Stazione Termini (train station), take the #64 bus to St. Peter's. Walk north and then west around the balustrade to the Vatican Museums entrance.

The Vatican took one of the most famous tauroctony, a sculpture of the bull-slaying with Mithra wearing a cape of stars and a quarter-moon, from the Fagan Mithraeum in Ostia and sequestered it in the Galleria Lapidaria (Gallery of Inscriptions). Located at the end of the Chiaramonti Museum, the gallery is open only to scholars. The Vatican contains other Mithra artifacts, including one in the Sala degli Animali, between the Egyptian and Etruscan museums.

I Nazareni

When the marchese Carlo Massimo decided to commission paintings of three Italian epic poems, he did not mean to start an epic story himself, one that undulates around serendipity, tragedy, religious fanaticism, and drama. In 1817, Massimo asked two German artists to paint the interior of his garden house in frescoes, a technique they and their "brothers" had come to Rome to study. By reviving the dead art, and walking the streets with long hair and flowing capes, and speaking feverishly of both art and religion, the painters had earned themselves the nickname *I Nazareni*, which eventually became more complimentary than the Romans had intended.

The movement began when Friedrich Johann Overbeck (1789–1869) and Franz Pforr (1788–1812) met at the Vienna Academy, where both young men chafed under the strict rules of aesthetics. With other rebels they started the Brotherhood of St. Luke, dedicated to representing the ideal in nature and in the creation and contemplation of art as a religious experience, not a fashionable gesture. In 1810 the two original founders moved to Rome, traveling with two other painters. Though the brotherhood's ranks grew, Overbeck and Pforr were coincidentally also the only Nazarenes to die in la Santa, as they called the city; the others eventually returned to Germany and its more lucrative commissions.

The Viennese foursome quickly welcomed into their fold other sympathetic artists, including Philipp Veit (1793–1877) and an important proponent of the new aesthetic, Peter Cornelius (1783–1867). Sharing food, models, women (for the less ascetic brothers), living quarters, and their first commis-

Koch, *The Inferno* (detail). A she-wolf, leopard, and lion threaten Dante.

sion, the painters solidified their religious and artistic under-pinnings. When Pforr died in 1812, the simple and natural idealist proved to have been the glue of the Order, as they often called themselves. The artistic commune disbanded. Though only the Nazarenes' second commission, the Casino Massimo's frescoes represent the apogee of the brotherhood's aesthetic expression.

The Nazarenes' first commission, the frescoes of *Joseph and His Brothers* that now hang in Berlin, spread their reputations quickly to Germany, and so began the drama of the Massimo rooms. The count offered the frescoes and subjects to Cornelius. He had completed only some sketches and cartoons before Prince Ludwig I of Bavaria offered the more attractive proposal of decorating the new Glyptotek in Munich. Graciously releasing Cornelius from his obligation, Count Massimo invited Joseph Anton Koch to complete the room, who instead suggested Veit.

Koch, *The Inferno* (detail). Demons torture the lost souls of Hell.

After Cornelius's studies, the oval ceiling fresco of Dante's *Paradiso* all but overwhelmed Veit's small talent as a draftsman of the human figure. Dante deserves livelier figures than the stuffed dolls to which Veit failed to give life. Often relegated to the medieval era, Dante actually heralds the birth of Renaissance painting when he declaims in *Purgatorio* that Giotto surpassed Cimabue in breaking the figure loose from Byzantine stiffness. Though Veit's clear colors demonstrate his technical sophistication and occasional superiority to the other Nazarenes in handling the lost medium of frescoes, he realized how he might fail to do justice to *L'Inferno* and *Il Purgatorio*. After working for four years on the *Paradiso* ceiling, he announced that he would not waste his talents on

painting Hell. He resigned the commission in 1824 and tossed the rest of the room back into Koch's lap.

Koch's resistance to painting the Dante Room is like the jilted Ariadne ignoring her new lover Bacchus because she feels too depressed to flirt: destiny had other ideas. A landscape painter, Koch had nonetheless already been sketching scenes from *The Divine Comedy* for over a dozen years. Why he did not leap at the offer of being paid to paint scenes from his favorite subject remains a mystery; could he have thought himself too much the Tyrolese peasant to approach the aristocrat of poets? In the end, he had to heed Dante's oft-repeated warning that no one can be saved from his fate; it is a gift. With stark outlines and indigenous colors, Koch embraced his gift and painted with such passion that the Massimo family muted him by painting over the figures' privates. He complained that "there were no tailors in Hell and Purgatory."

Koch, *The Inferno* (detail). Satan's reign.

Koch, *The Inferno* (detail). A snake gnaws eternally at the damned.

Veit, *Paradiso* (detail). Beatrice with the head of Christ in her hands.

When Count Massimo first commissioned the Dante Room, he also offered the Tasso Room and its depiction of Jerusalem liberated to Overbeck. The founding Nazarene had converted to Catholicism with the deeply pious attitude of, well, converts. Overbeck suffered from fevers, first of the body, then of the mind, as he flinched from what he considered indecent depictions of the paean to Christianity. When Count Massimo died in early 1827, Overbeck grasped at the excuse to abandon what he considered a repugnant chore. He fled to Assisi to make amends to the patron saint of ascetic Catholics, St. Francis, with a fresco, *The Miracle of the Roses*, on the Porziuncola Chapel.

Overbeck designated Joseph von Führich as his worthy successor. As the young painter's first major work, the Tasso Room offered a monumental challenge: realize both the patrons' and Overbeck's ideas while shoehorning in new ones, such as portraits of the Massimo family in front of Christ's tomb.

To paint the scenes from *Orlando furioso,* Massimo had chosen an Italian artist who died before he could start. (The toll in the Massimo frescoes was one painter lost to money, two to faint-heartedness, and a painter and a patron to death.) The count turned to Julius Schnorr von Carolsfeld (1794–1872) to start the rooms. The painter remained undecided about accepting what was the largest of the Massimo commissions due to his own ill health and his desire to study art, rather than to paint, in Rome. The Italian painter's sudden death decided it for him. Schnorr thus became the only Nazarene artist to start and complete a Massimo room.

The artists changed, but the epic poems remained the same: *La divina commedia* by Dante Alighieri (1265–1321), *Gerusalemme liberata* by Torquato Tasso (1544–1595), and *Orlando furioso* (or *The Siege of Paris*) by Ludovico Ariosto (1474–1533). Yet the very act of stuffing epic poetry into modest rooms has caused the Nazarenes' Massimo frescoes to

Veit, *Paradiso* (detail). Dante humbled before the saints.

Schnorr, the Ariosto Room (detail). Charlemagne's army during its siege of Paris.

be dismissed as trivial. Art critics voiced reservations even as the painters worked.

Critics believed that each new era must demonstrate some innovation in artistic technique, philosophy, goal, or medium. Instead, the young Germans purposefully jumped off the forward march of painting by quitting the academy. They chose to run backward past Titian, Correggio, and Andrea del Sarto to Raphael, the medieval Germans, and Giotto. They personally raised Raphael from the dust heap of surpassed painters, resuscitating him as one of the eternal masters whom all artists benefit from studying.

The artists strove not to become greater than any other painters in the sophistication of their techniques and the real-

istic beauty of their images. Instead, they were interested in exciting religious, not worldly, passion and in serving the public good more than their own vanity as artists. Despite their atavistic techniques and purposes, their choice of setting broke the aesthetic mold. Even though they did not choose the commission and the topics, which Count Massimo had selected himself before looking for the painters, they did choose how to interpret the poetry. Instead of compromising the epic figure traditional to frescoes and drawing on a smaller scale to fit the garden house's rooms, the artists sketched enormous cartoons, more fitting to a much larger wall of a palace or church. They created an entirely new aesthetic, a re-creation of the literary experience.

The Nazarenes returned to a time when patrons had huge walls to fresco and the illiterate common folk needed stories

Schnorr, the Ariosto Room (detail). Battle during the Siege of Paris (left) and Fiordiligi and Brandimarte (right) reveal a love that binds them together even in death.

Schnorr, the Ariosto Room (detail). Charlemagne's army during its siege
of Paris.

told in images, a time that burgeoning democracy drew to a permanent close within a century. Strangely enough, history has brought us full circle. While modern travelers can read, they are not what the nineteenth century called literate. High school students no longer memorize as part of their standard curriculum passages of *The Divine Comedy*, which John Ciardi (my favorite translator) calls "the greatest poem of the Middle Ages and the first masterpiece of world literature written in a modern European language." Few Americans know of Ariosto, called "the Italian Homer," or Tasso, the greatest Italian poet of the sixteenth century. (Neither poet even makes a listing in E. D. Hirsch, Jr.'s *The Dictionary of Cultural Literacy: What Every American Needs to Know*.)

The Nazarene frescoes today fulfill their original purpose: to educate with frescoed Cliff Notes. In the Dante Room, the scenes in *La divina commedia* include two walls dedicated to *L'Inferno*: The north wall begins the autobiographical fable with Dante asleep, wild beasts threatening him as he attempts to climb straight to the Mount of Joy, and Virgil saving him, to escort him to Joy by a long, arduous route. On the west wall, the two poets travel through Hell clinging to the back of the "sharp-tailed beast," which Dante called a male but which Koch portrays as a half-woman, half-dragon that looks like Echidna. Below, devils and snakes play with exotic tortures to make the damned writhe and scream. Koch abbreviates *Purgatory* from its beginning, in which an

angel pilots the ship of saved souls to the Mount of Purgatory, to its ninth canto, when the guardian of the Golden Gates etches seven P's into Dante's forehead, signs of the seven deadly sins. The ceiling dedicates itself to Dante in *Paradiso*, where Virgil could not enter. Dante's beloved Beatrice acts as his new escort.

Schnorr, the Ariosto Room, *The Siege of Paris* (detail).

In Schnorr's depiction of Ariosto's *The Siege of Paris* in the middle room, Parisians watch as Charlemagne and his army enter the city on the central wall. They conduct themselves in that nonchalant manner common to all noncombatants by keeping themselves fed and watered and alive. On the left wall, Orlando's "frenzy" erupts when he realizes that his love for Angelica, the pagan daughter of the Great Khan, is forever unrequited. The much-pursued Angelica sits with her beloved Medoro, India's future king, as Orlando goes insane below them.

On the ceiling in the lower lunette, St. John the Evangelist and Astolfo return from the moon in Elijah's chariot with a vase containing Orlando's sanity. Fiordiligi stares longingly at Brandimarte (left lunette), whom she loves so much she entombs herself with him rather than let death do them part. In the right lunette, Zerbino, son of the king of Scotland, and Isabella recognize each other beneath their helmets and reunite in love. Zerbino at first fears that Orlando, Isabella's escort, has taken her as a lover. She reassures him, "Dispelling all his pain, / How Count Orlando honors and reveres / A damsel in distress," when it was not yet a cliché.

The ceiling encompasses many of the poem's themes in a single figure. Melissa's uplifted arm reveals her superior power as she sits between Atlante and the hippogriff and Alcina. The good sorceress's first act in *Orlando* is to aid the Christian warrior Bradamante (right lunette), also called the Maid, in seeing her fate as a heroine. Atlante tames the winged horse and carries a shield with a beam that knocks every victim unconscious except the immune Bradamante. The evil sorceress Alcina seduces and almost enslaves Ruggiero on her island, but he escapes to reunite with his true love, Bradamante. Marfisa, who passes as a cavalier to those who do not know "her true sex nor her true worth," is on the left. In the center of the ceiling Schnorr illustrates the marriage between Ruggiero and Bradamante that Charlemagne and his paladins witness. Ariosto's patrons, the d'Este of Ferrara, claimed that union started their line, a boast the poet is careful to repeat occasionally in the forty-six cantos.

The Tasso Room illustrates the poem *The Recovery of Jerusalem*, or its *Siege*, according to one's perspective, from the Egyptians, whom Tasso refers to as Turks. (Many Italians still mash together nationalities and identities: Anyone blond is

Fürich, the Tasso Room, *Rinaldo's Disenchantment of the Magic Forest* **(detail).**

automatically a *tedesco,* or German.) The First Crusade set-
tled in front of the walls of Jerusalem on June 7, 1099, and
built towers to vault the walls and seize the city away from
the Fatimids. The other frescoes illustrate such large-scale
themes as the love between Rinaldo and Armida as they share
the fighting field (left wall) and such small victories as the
shepherds who comfort Erminia after her flight from her per-
sonal beloved and her people's enemy, Tancred.

Tasso chooses to illustrate another cliff-hanging episode between lovers on the ceiling. Olindo agrees to share the martyr's fire with his love Sophronia; the Saracen commander and queen, Clorinda, orders the torches quenched. Overbeck selected the ceiling's vignette from among the saga's almost two thousand ottava rimas:

> *Sophronia and Olindo would be slain*
> *To save the rest, the King grants their desire;*
> *Clorinda hears their fact and fortunes plain,*
> *Their pardon gets and keeps them from the fire.*
>
> —Torquato Tasso, *Gerusalemme liberata*, II, Argument

Another leitmotiv that floats through *Gerusalemme* is the shared love, battles, and deaths of the *"amori e sposi"* (lovers and spouses) Edward and Gildippe. When Gildippe dies under the hand of Prince Suleiman (left wall), Edward dies trying to save her. The "Turk" recognizes Gildippe's armor and, after she deals him a few wounding blows, swears at her before cutting her down:

> *"See, see this mankind strumpet, see," he cried,*
> *"This shameless whore, for thee fit weapons were*
> *Thy needle and spindle, not a sword and spear."*
>
> —*Gerusalemme liberata*, XX, 95

Edward, or Odoardo in Italian, attempts to kill the prince but cannot let go of his dying wife:

> *Too weak his will and power divided were;*
> *So that he could not his fair love uphold,*
> *Nor kill the cruel man that slew his dear.*

Overbeck, the Tasso Room, *The Liberation of Jerusalem* **(detail). Rinaldo and Armida on the battlefield.**

His arm that did his mistress kind enfold,
The Turk cut off, pale grew his looks and cheer,
He let her fall, himself fell by her side,
And, for he could not save her, with her died.

—*Gerusalemme liberata*, XX, 98

Overbeck, the Tasso Room, *Olindo and Sophronia at the Stake* (detail).

The Nazarenes dispersed as a movement by the time they had completed—or abandoned—the Massimo frescoes in 1828, almost two decades after the first foursome had arrived in Rome. Once they returned home, Schnorr and Cornelius had a profound but short-lived influence on German art.

Only Overbeck remained in la Santa to greet fellow artists and thus ensure the Nazarenes' international influence after the 1848–49 Germanic revolutions. In 1845, Ford Madox Brown visited Rome and first saw Overbeck's works: "The sentiment of his art was so vivid, so unlike most other art, that one . . . could not see enough of it." Though Brown never officially joined the Pre-Raphaelites, he influenced them by becoming Dante Gabriel Rossetti's first teacher and writing for their journal, *The Germ*, about the Nazarenes.

Tasso and Ariosto influenced Milton in the seventeenth century, Casanova in the eighteenth, and in the nineteenth Sir Walter Scott, who revived general interest in the epic romances. By the twentieth century the poets had utterly lost their influence on Western culture. Strange that both the Nazarenes and the Italian poets, except for Dante, have had the same shelf life, and that their works have disappeared from the general public's knowledge. Appropriately, the Franciscans safeguard the frescoes from annihilation, as it has been monks' voluntary role since the Dark Ages to preserve much knowledge and art from ignorance and its consequence, death.

Casino Massimo

Via Boiardo, 16

Hours: Tuesday and Thursday 9 A.M.–noon and 4 –7 P.M.;
Sunday 10 A.M.–noon.

Getting There: Take the metro to the Manzoni station. Turn left onto Viale A. Manzone, and take the second left onto Via Boiardo. The monastery is on the right, with a plaque announcing its hours for opening the Dante and other rooms.

Caution: The word *casino* is not meant for polite company. It means a brothel. Better to refer to it as the Monastery of the Franciscan Brothers of the Sacred Earth (Francescani di Terra Santa).

(or How to Find Your Own Hidden Treasures)

As with most of life, the secret to finding hidden art treasures in Italy is to read, read, read. In my introduction I mention Giorgio Vasari's **Lives of the Painters, Sculptors and Architects** (New York: Knopf, 1996) as an excellent source in which to learn about artists you like. Unlike the usual travel method of deciding to go to certain cities and figuring out what to see there, defining a trip by art rather than geography can deepen the meaning and purpose of your travels.

If already committed to an itinerary, then search your local bookstore or library for guides that focus on the cities you plan to visit. Or find out what is in the smaller cities surrounding the major ones by browsing through Paul Hofmann's still excellent **Cento Città: A Guide to the "Hundred Cities and Towns" of Italy** (New York, Henry Holt, 1991). He'll give you a general sense of the town's history and present-day ambience before you plunge into a day's side trip.

I always recommend not only seeing the usual sites but seeing them repeatedly. On one trip to Rome my husband visited the Pantheon five times. Walking along a city's normal tourist route does not, however, preclude finding obscure paintings and sculpture. When traveling from the Vatican to the Pantheon, for example, you can use **Blue Guide Rome** (New York: W. W. Norton, 2001), **Knopf Guide Rome** (New York: Knopf, 1994), **Baedeker's Rome** (especially the nineteenth-century to mid-twentieth-century editions), **City Secrets: Rome** (New York: The Little Bookroom, 2000), or even John Varriano's **A Literary Companion to Rome** (New York:

St. Martin's, 1995) to find half a dozen churches and ruins worth exploring on the way. Fanatics reach for Guida d'Italia's cardinal-red-covered **Roma** (Milan: Touring Club Italiano, 1999), which describes everything in the city (it is the only guide I have found that lists the Nazarene rooms at Casino Massimo) in a thousand pages of six-point type plus fold-out maps stuffed into side pockets—a hefty hardback that still fits in a purse. Unfortunately, it is only available in Italian.

Whenever I arrive in an Italian city I usually visit a bookstore to see what the English-language guides might have left out. One year the nearest bookstore to my Rome hotel was dedicated to archaeology, and there I found the photos of the impenetrable mithraeums in Carlo Pavia's **Guida dei mitrei di Roma antica: dai misteriosi sotterranei della capitale: oro, incenso e mithra** (Rome: Gangemi, 1999). His excellent books on the mithraeums are only in Italian, but many English-language books explore the religious and historical meaning of the Houses of Mithra, including Franz Cumot's classic, **The Mysteries of Mithra** (New York: Dover, 1956). A more contemporary interpretation of Mithra as a reflection of astronomical discoveries at the turn of the millennium is David Ulansey's **The Origins of the Mithraic Mysteries: Cosmology and Salvation in the Ancient World** (Oxford: Oxford University Press, 1990). Ulansey suggests that astronomers turned to astrology to explain the shifting con-stellations, and thus transformed Mithra into Perseus.

Museum bookstores are always a mother lode of dis-covery. I usually visit a museum's bookstore before touring the collection; they often stock scholarly works on little-known pieces in their collection that focus my attention. If I had not stopped in the Castello Sforzesco's bookstore I might not have scrutinized the compelling details about the

Trivulzio Tapestries of the Months that Nello Forti Grazzini reveals with humor and knowledge in his *Gli Arazzi dei mesi Trivulzio: il committente, l'iconografia* (Milan: Comune di Milano Ripartizione Cultura e Spettacolo, 1982).

Even the general photo-laden books on a collection help to highlight the works' beauty that you might miss, especially in those Italian museums that still cling to their dark and dingy centuries-old ways. At La Specola in Florence, for example, the *Encyclopaedia anatomica* (Monika V. During, et al., Koln: Paschen, 1999), which features Saulo Bambi's stunningly beautiful photos of the anatomical wax models as works of art, helped me to appreciate the figures before walking into the Museo di Storia Naturale. The museum displays them in glass cases and on faded backdrops that sometimes combine to make the models difficult to see at all. *The Encyclopaedia*'s essays are in English as well as Italian.

After browsing a museum store's books, I glance through its postcards. In fact, I often stop to look through postcards when I first arrive in a city to see what the natives think is worth visiting. From Verona's Castelvecchio, for example, the postcard of Giovanni Francesco Caroto's (c. 1480–1555) *Giovane con disegno a pupazzo* (Portrait of a Boy and His Drawing of a Doll) hangs on my refrigerator all year, and I visit the original first and last when touring the castle. I have never seen it reproduced outside of Verona, and yet every morning it wakes up my heart better than coffee.

Hidden treasures are not only buildings, sculpture, paintings, gardens, and tapestries, they are also within the works themselves. Usually, art historians have found them first and tell you about them in monographs. For example, for the works in the Ducal Palace, I could have depended on just the standard guidebook, *The Palazzo Ducale in Mantua* (Milan:

Electa, 1992). But in **Mantegna's Camera degli Sposi** (New York: Abbeville, 1993), edited by Michele Cordaro, I discovered that the putti in the Camera di Pinta sprout butterfly wings of particular species. Giovanni Paccagnini's **Pisanello** (New York: Phaidon, 1973) enlightened me as to the chivalric tale behind the Quattrocento frescoes. Raphael's *Acts of the Apostles* required a preliminary reading of John Shearman's **Raphael's Cartoons in the Collection of Her Majesty the Queen, and the Tapestries for the Sistine Chapel** (London: Phaidon, 1972) to understand the history and aesthetic assumptions behind the tapestries. In Rome, Paolo Portoghesi in his **The Rome of Borromini** (New York: George Baziller, 1968) casually mentions the view when climbing up the spiraling cupola of Sant'Ivo in the early sixties, while Keith Andrews's **I Nazareni** (Milano: Fabbri, 1967) provided a biography for each of the Nazarene brothers and their works at the Casino Massimo. Obviously, no general guidebook can provide that kind of detail.

Finally, I highly recommend browsing the Web, subscribing to e-mail newslists, and reading magazines dedicated to art in Italy. The most luscious of the serials is **FMR**, which concentrates mostly on Italian art, but also reveals beauties from all over the world in architecture, porcelain, masks . . . everything touched and touched well by artists. Before pinning down your travel plans, I recommend an afternoon of browsing through the **FMR**s with a notepad and pen and dream beside you. Better yet, skip your birthday dinner and use the money to subscribe; it will feel as if you have dined at the Uffizi Palace every month when the thick shiny black magazine arrives in your mailbox.

INDEX

Caroto, *Giovane con disegno a pupazzo*
(Portrait of a Boy and His Drawing of a Doll).